Drawing Flowers

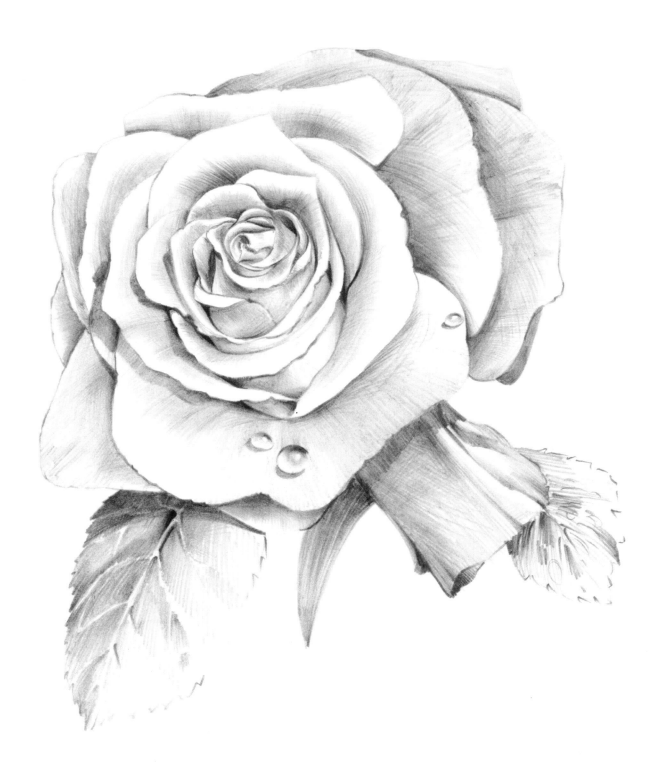

Illustrated by
William F. Powell

Walter Foster Publishing, Inc.

Getting Started

Drawing is just like writing your name. You use lines to make shapes. In the art of drawing, you carry it a bit further, using shading techniques to create the illusion of three-dimensional form.

Only a few basic tools are needed in the art of drawing. The tools necessary to create the drawings in this book are all shown here.

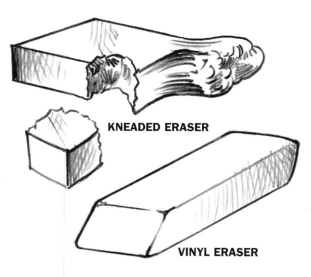

KNEADED ERASER

VINYL ERASER

Pencils

Pencils come in varying degrees of lead, from very soft to hard (e.g., 6B, 4B, 2B, and HB, respectively). Harder leads create lighter lines and are used to make preliminary sketches. Softer leads are usually used for shading.

Flat sketching pencils are very helpful; they can create wide or thin lines, and even dots. Find one with a B lead, the degree of softness between HB and 2B.

Although pencil is the primary tool used for drawing, don't limit yourself. Try using charcoal, colored pencils, crayons, and pastels–they can add color and dimension to your work.

Erasers

Erasers are not only useful for correcting mistakes, but they are also fine drawing tools. Choose from several types: kneaded, vinyl, gum, or rubber, depending on how you want to use the eraser. For example, you can mold a kneaded eraser into a point or break off smaller pieces to lift out highlights or create texture. A gum or rubber eraser works well for erasing larger areas.

Other Helpful Materials

You should have a paper blending stump (also known as a *tortillon*) for creating textures and blends in your drawing. It enhances certain effects and, once covered with lead, can be used to draw smeared lines.

Since you should conserve your lead, have some sandpaper on hand so you can sharpen the lead without wearing down the pencil. You may want to buy a metal ruler, as well, for drawing straight lines. Lastly, a sturdy drawing board provides a stable surface for your drawing.

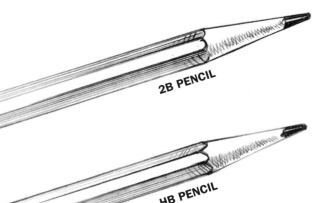

2B PENCIL

HB PENCIL

FLAT SKETCHING PENCIL

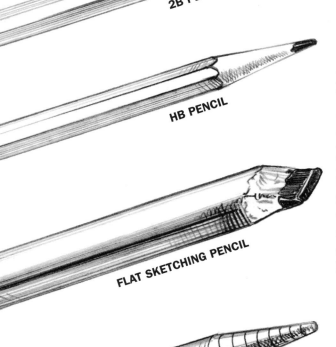

PAPER STUMP/TORTILLON

SANDPAPER PAD

Final Preparations

Before you begin drawing, set up a spacious work area that has plenty of natural light. Make sure all your tools and materials are easily accessible from where you're sitting. Since you might be sitting for hours at a time, find a comfortable chair.

If you wish, tape the paper at the corners to your drawing board or surface to prevent it from moving while you work. You can also use a ruler to make a light border around the edge of the paper; this will help you use the space on your paper wisely, especially if you want to frame or mat the finished product.

Paper

There are many types of paper that vary according to color, thickness, and surface quality (e.g., smooth or rough). Use a sketch pad or inexpensive bond paper for practice. For finer renderings, try illustration or bristol board. Bristol board is available in plate finish, which is smooth, or vellum finish, which has more tooth. As you become more comfortable with drawing techniques, experiment with better quality paper to see how it affects your work.

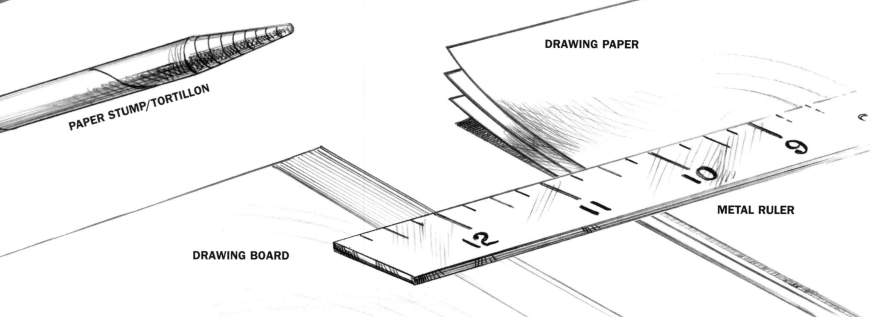

DRAWING PAPER

METAL RULER

DRAWING BOARD

Shading Techniques

Shading enables you to transform mere lines and shapes in your drawing into three-dimensional objects. As you read through this book, note how the words *shape* and *form* are used. *Shape* refers to the actual outline of an object, while *form* refers to its three-dimensional appearance. See the examples below.

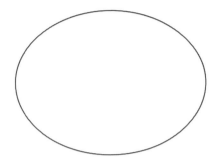

This is an oval *shape*.

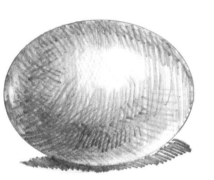

This has a three-dimensional, ball-like *form*.

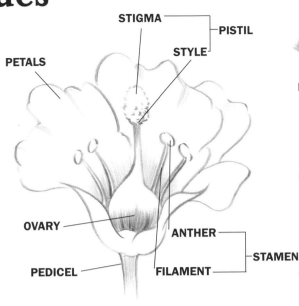

The diagram above illustrates the various shapes of the flower parts, which you should study closely before drawing. With effective shading you can bring out their individual forms.

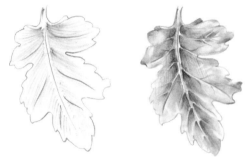

As you shade, follow the angle of the object's surface, and blend to allow the texture to emerge.

As you can see, pencils can be used with sharp, round, flat, and blunt points, and several techniques can be combined on one surface. The paper stump helps smear the lead, making a blend softer. Experiment and see what kinds of textures you can create on your own.

Note the different kinds of lines each type of drawing tool can create.

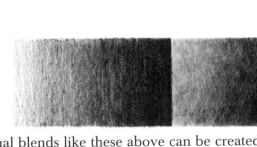

FLAT SKETCH

ROUND SHARPENED FLAT

TIP OF SHARP ROUND

SIDE OF THE ROUND

BLUNT ROUND

PAPER STUMP/TORTILLON

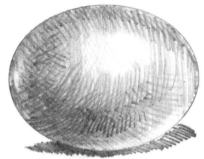

Make patterns like the ones above using the side, rounded tip, and sharpened point of an HB pencil. Shade backgrounds first; then draw patterns over them. Pressing harder creates darker effects.

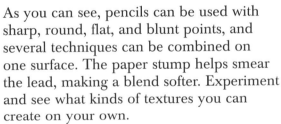

Gradual blends like these above can be created using the side of a 2B pencil. Shade in one direction to make the vertical finish on the left. On the right, see that two "blend angles" produce a smoother finish. Start lightly and increase pressure as you work to the right.

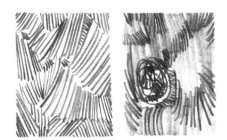

Left: Use a sharp-pointed HB to draw this line pattern. **Right:** Shade a light background with a round-pointed HB. Then use a sharp-pointed one to draw the darker, short lines over the background.

Left: Draw groups of randomly patterned lines using a round HB lead. **Right:** Use the side of an HB to shade the background, blend with a paper stump, then add patterned lines over the background.

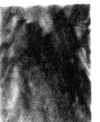

Left: Create blends and lines like these with a blunt round 2B pencil. **Right:** Use the same technique as the left example, then blend softly with your finger or a paper stump.

Left and right: Make lighter background shading using the side of a 2B. Then apply a little more pressure for the darker patterns, varying the pencil angle.

Pictorial Compositions

You can use a variety of techniques to design an interesting composition. Place different lines and shapes in various angles on your paper. You'll see how composition deliberately directs the eye to the center of interest.

It's important to place objects in a manner that creates a center of interest. A circle or elliptical design always leads the eye around the composition, as shown in the example below.

In this next example, placing differently sized ellipses together in a circular arrangement can make a composition appealing and help hold attention.

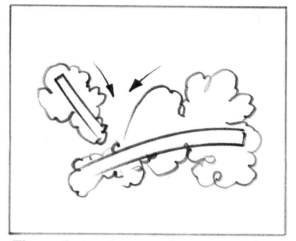

The explosive design in the center of the page is engaging because the eye automatically goes to the center of the composition.

The composition below draws attention to the center by using a U shape. The object area on the right is larger than the left, but a balance is achieved by placing more open space in the left center area.

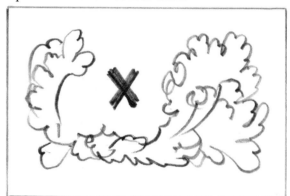

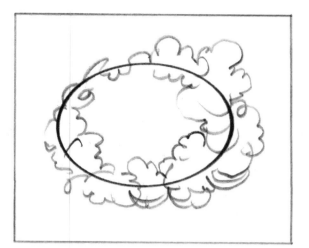

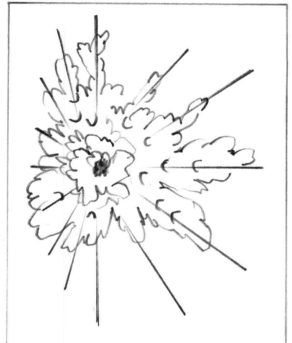

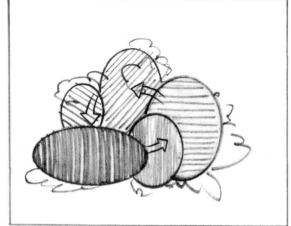

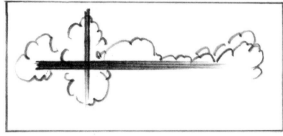

The horizontal cross in the example above creates a serene feeling in contrast to the speed and action conveyed in the composition below.

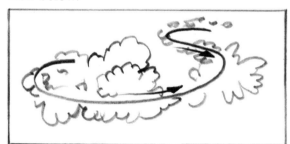

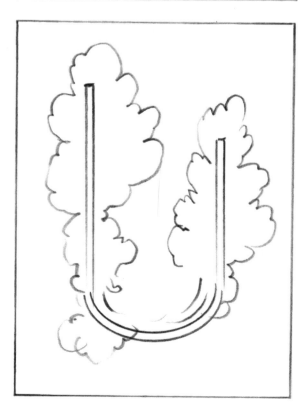

Letters of the alphabet are fine composition tools. For example, flowers and other subjects can be pleasing when arranged in an uneven U shape.

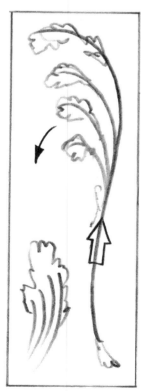 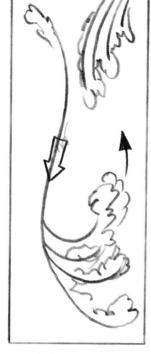

Draw this composition, and then flip it over to get its companion piece, as shown above. Notice the movement established within the two panels.

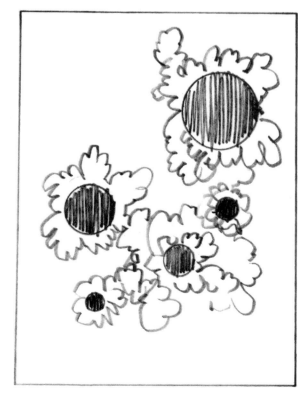

Different-sized flowers placed strategically within a composition produce rhythm. Balance flower shapes and sizes against one another around the composition.

Flower Arrangements

The diagrams below can be helpful in setting up well-balanced flower arrangements. Take snapshots of fresh flowers, and set up a reference file, known as a *morgue,* for them. You might also want to shoot your arrangements from various angles—close up, far away, from above or below—so you can create different compositions from the same drawing subject.

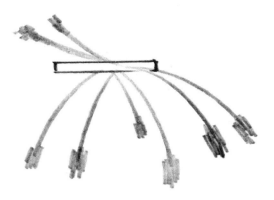

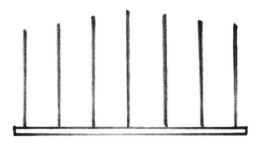

Vertical parallelism is regal and makes a unique arrangement. Try to maintain uniform spacing in this pattern.

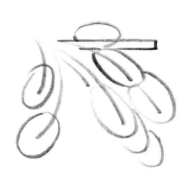

The examples above are variations of the oriental style.

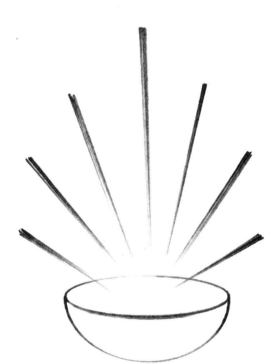

A round bowl can be a perfect center point from which an arrangement moves upward and outward. Try to achieve an overall balance.

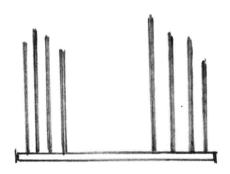

This arrangement has an open or "negative" space in the center and should be used to balance the positive space.

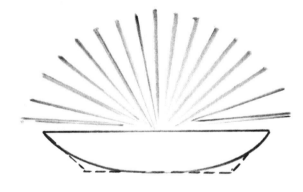

Many types of flowers will fit into this uniform, arching design. Try to maintain an even curve at the top.

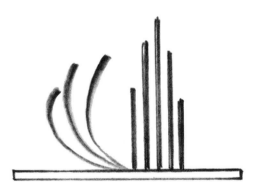

Using curved and straight lines together is interesting. The static verticals in this arrangement oppose the curves to create a successful and pleasing balance.

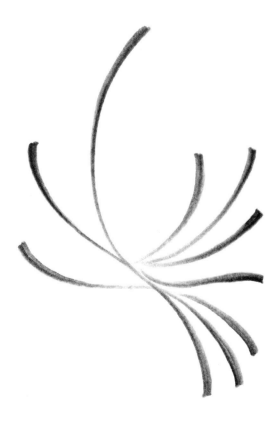

The design above is based upon an oriental arrangement style. The tall center flower represents heaven. The downward lines symbolize deviations, while the others represent earth and man.

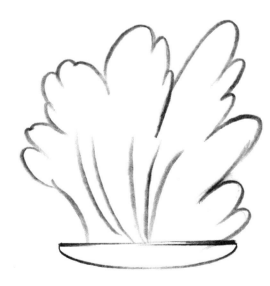

Cloud designs are always pleasing arrangements. Study and sketch cloud formations, and keep proportion and balance in mind when using this design.

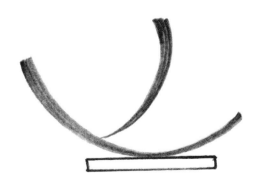

Notice how this graceful balance of curved lines is complemented by the horizontal base.

Basic Flower Shapes

As you can see, even the most complicated flowers can be developed from simple shapes. Select a flower you wish to draw and study it closely, looking for its overall shape. Sketch the outline of this shape, and begin to look for the other shapes within the flower. Block in the smaller shapes that make up details, such as petals or leaves. Once you've completed this, smooth out your lines and begin the shading process.

Front View **Angle View** **Side View**

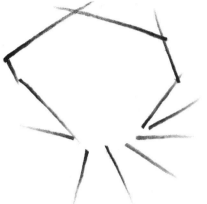

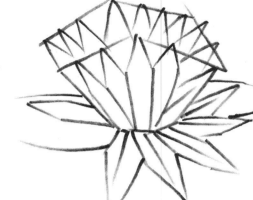

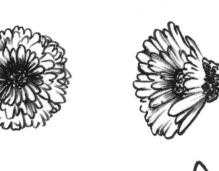

A. Sketch the basic shape.

C. Add details.

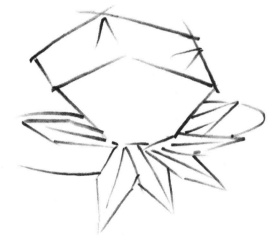

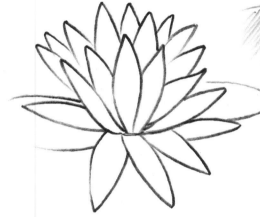

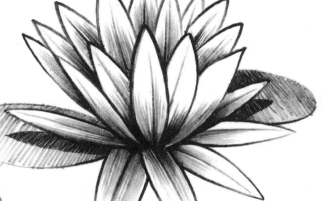

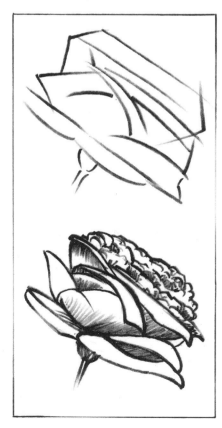

B. Block in smaller shapes.

D. Clean up the lines.

E. Create form by shading.

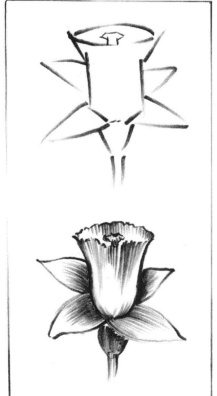

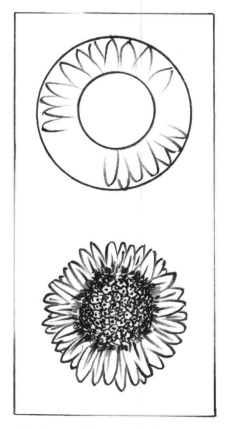

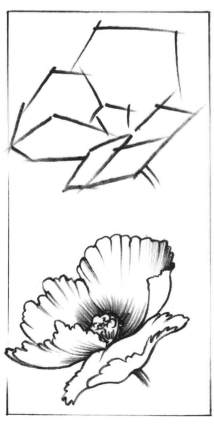

With an HB pencil, sketch the cup-like shape of the flower first; then place the petals and stem, as shown above. Begin developing the form with shading.

Circles enable you to draw round flowers. Set the size with a large circle, and place a smaller one inside. Using them as a guide, shade details.

This three-quarter view may seem more difficult to draw, but you can still bring out its basic shapes if you study it carefully. Begin each petal with short lines drawn at the proper angles.

Drawing flowers with many overlapping petals is more involved but, once the basic shapes are sketched in, the details can easily be drawn.

Tulips

There are several classes of tulips with differently shaped flowers. The one below, known as a parrot tulip, has less of a cup than the tulip to the right and is more complex to draw. Use the layout steps shown here, before drawing the details.

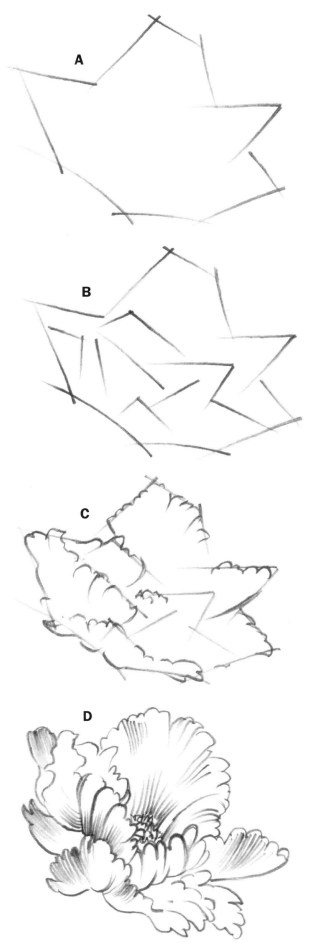

A

B

C

D

For the tulip above, begin step A using straight lines from point to point to capture the major shape of the flower. Add petal angles in step B. Draw in actual petal shapes in step C, and complete with simple shading in step D.

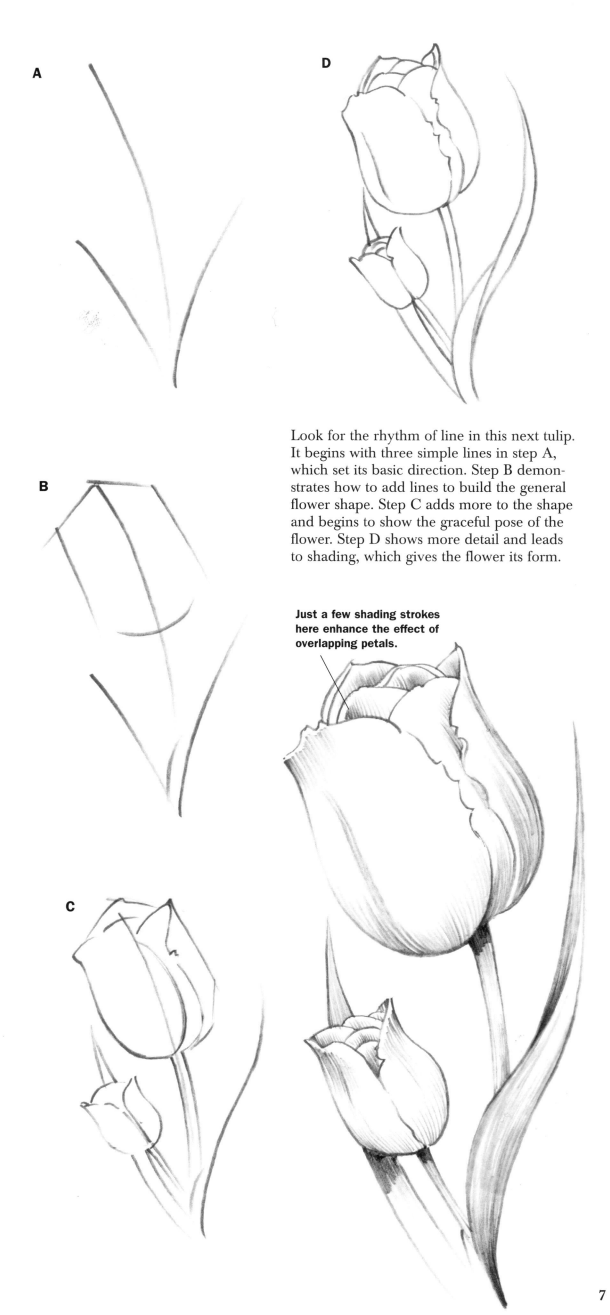

A

B

C

D

Look for the rhythm of line in this next tulip. It begins with three simple lines in step A, which set its basic direction. Step B demonstrates how to add lines to build the general flower shape. Step C adds more to the shape and begins to show the graceful pose of the flower. Step D shows more detail and leads to shading, which gives the flower its form.

Just a few shading strokes here enhance the effect of overlapping petals.

Magnolia

The magnolia grandiflora is a large, white, fragrant flower. To make the flower blossom stand out, keep the shading of its petals to a minimum, and shade the leaves underneath darker.

Draw a six-sided shape first. Then use the corners of the shape to position the larger petals, and add detail and shading.

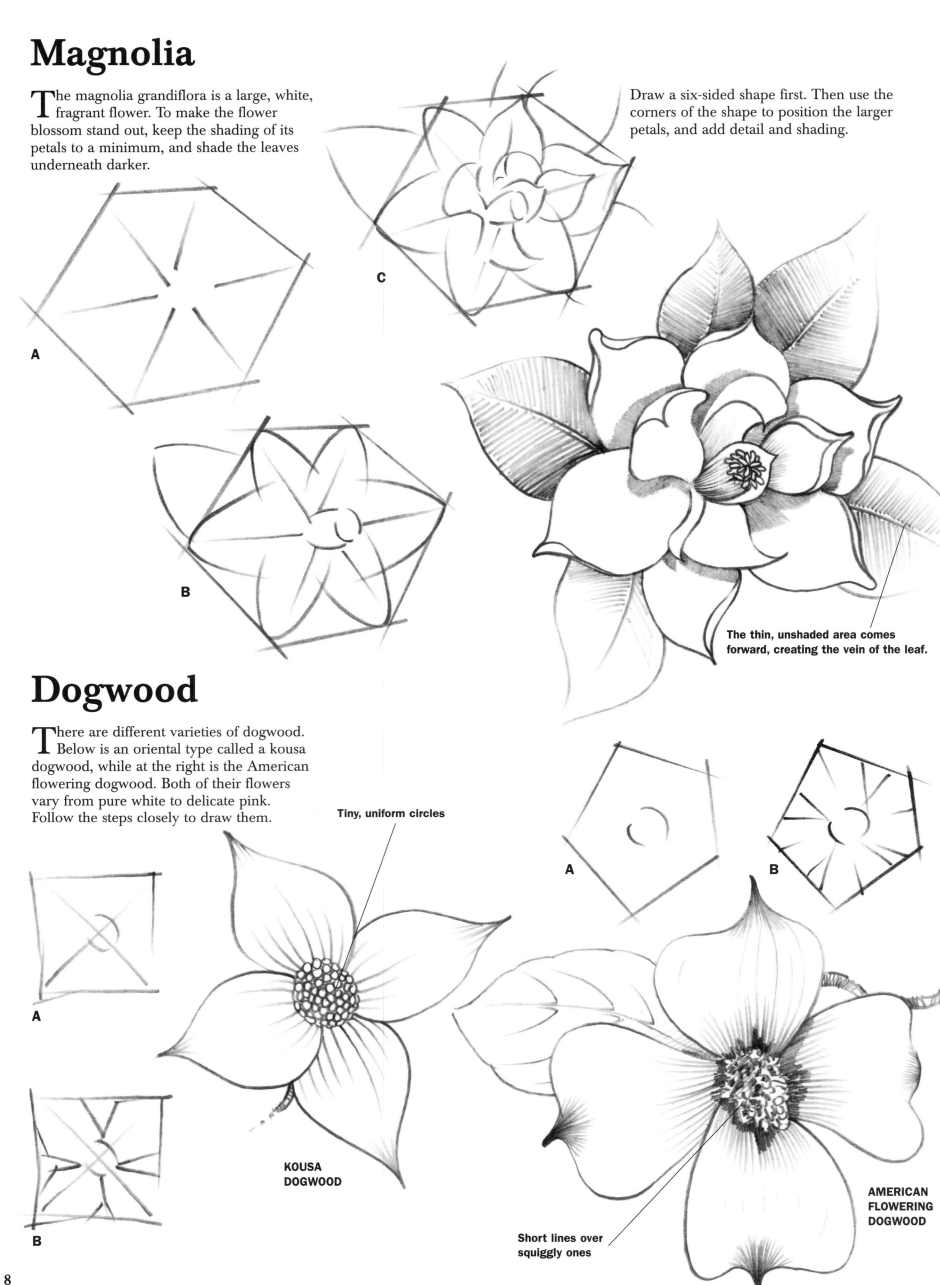

A

B

C

The thin, unshaded area comes forward, creating the vein of the leaf.

Dogwood

There are different varieties of dogwood. Below is an oriental type called a kousa dogwood, while at the right is the American flowering dogwood. Both of their flowers vary from pure white to delicate pink. Follow the steps closely to draw them.

Tiny, uniform circles

A

B

A

B

KOUSA DOGWOOD

AMERICAN FLOWERING DOGWOOD

Short lines over squiggly ones

Regal Lily

Lilies are very fragrant, and the plants can grow up to eight feet tall. Use the steps below to develop the flower, which you can attach to the main stem when drawing the entire plant, as shown at the bottom of the page.

A

B

C

D

LILY BUD

A

B

The lily bud in step A above starts out completely closed. Step B illustrates the two angles you should shade to give the bud form. It also shows how to transform the bud so it appears slightly opened. Add these types of buds to your lily plant, paying attention to how they attach to the stems.

Shading lines like these illustrate a technique called *crosshatching* and give the petals form.

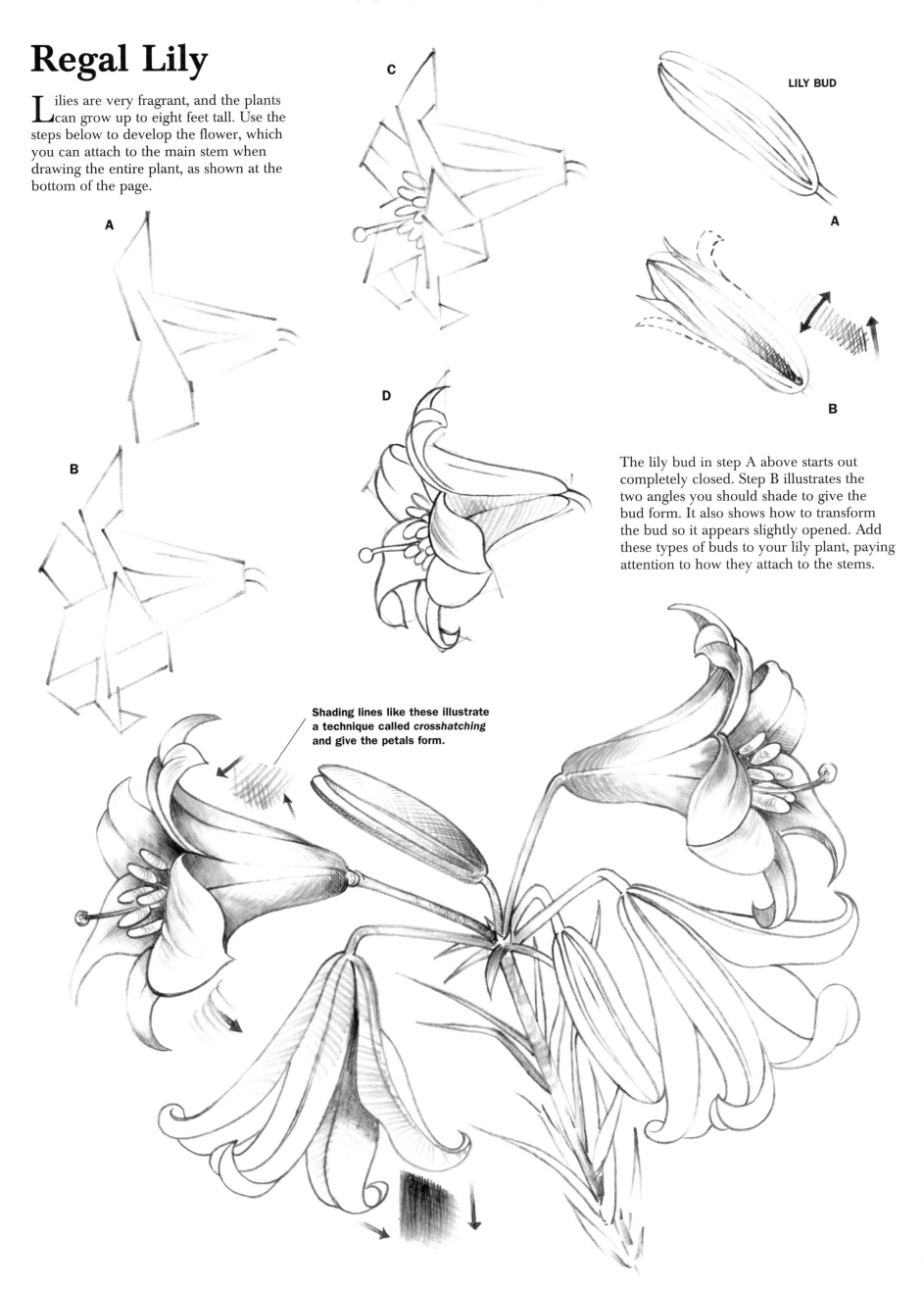

Daffodil

The flower shown here is a trumpet daffodil, of which there are large- and small-cupped varieties. The horn-like opening of this flower enhances its charm. Follow the steps closely in this exercise and you will end up with a perfect drawing. Begin step A by drawing the horn shape.

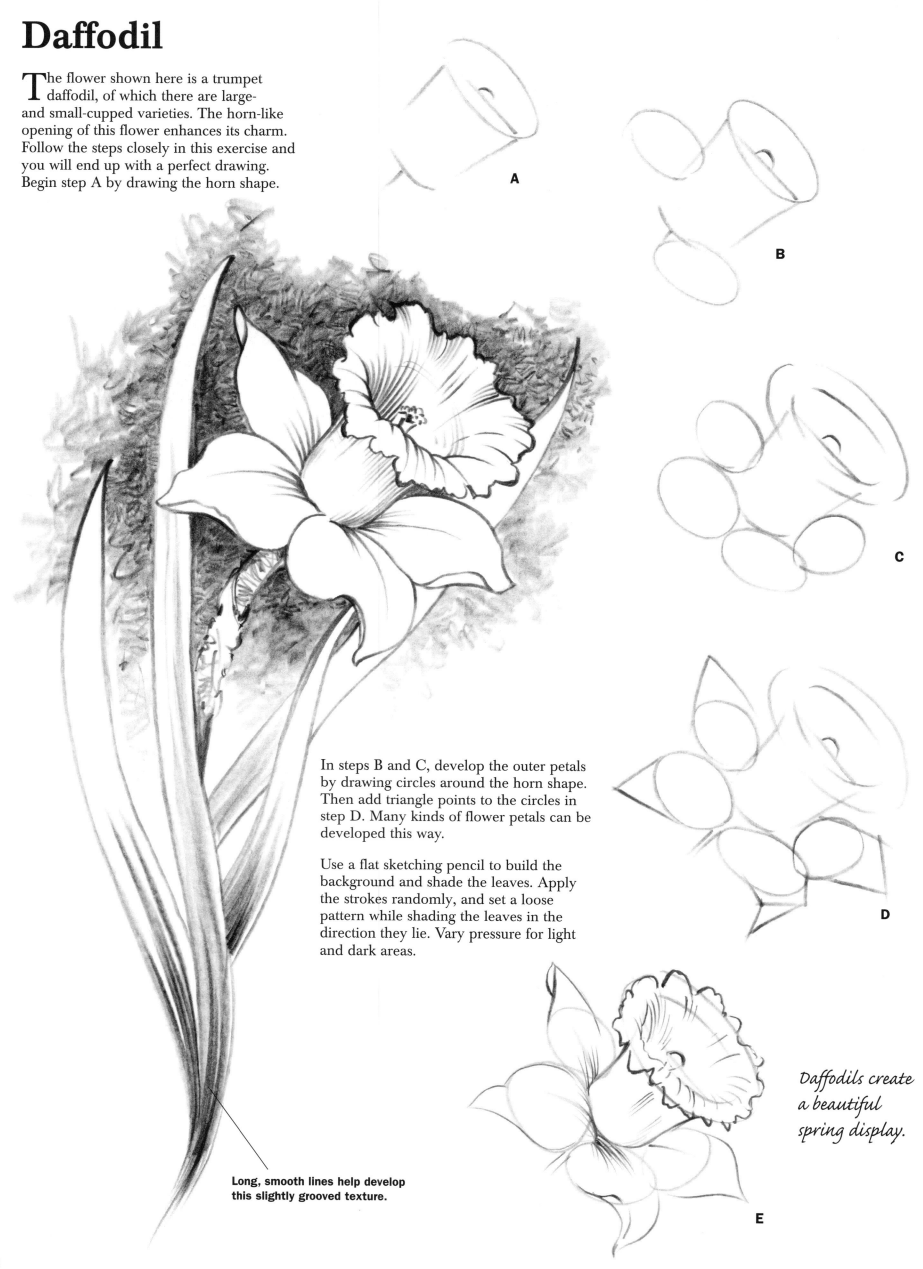

A

B

C

In steps B and C, develop the outer petals by drawing circles around the horn shape. Then add triangle points to the circles in step D. Many kinds of flower petals can be developed this way.

Use a flat sketching pencil to build the background and shade the leaves. Apply the strokes randomly, and set a loose pattern while shading the leaves in the direction they lie. Vary pressure for light and dark areas.

D

Long, smooth lines help develop this slightly grooved texture.

Daffodils create a beautiful spring display.

E

Carnation

Carnation varieties range from deep red to bicolored to white. They are very showy and easy to grow in most gardens. They are also fun and challenging to draw because of their many overlaying petals. Shade them solid, variegated, or with a light or dark edge at the end of each petal.

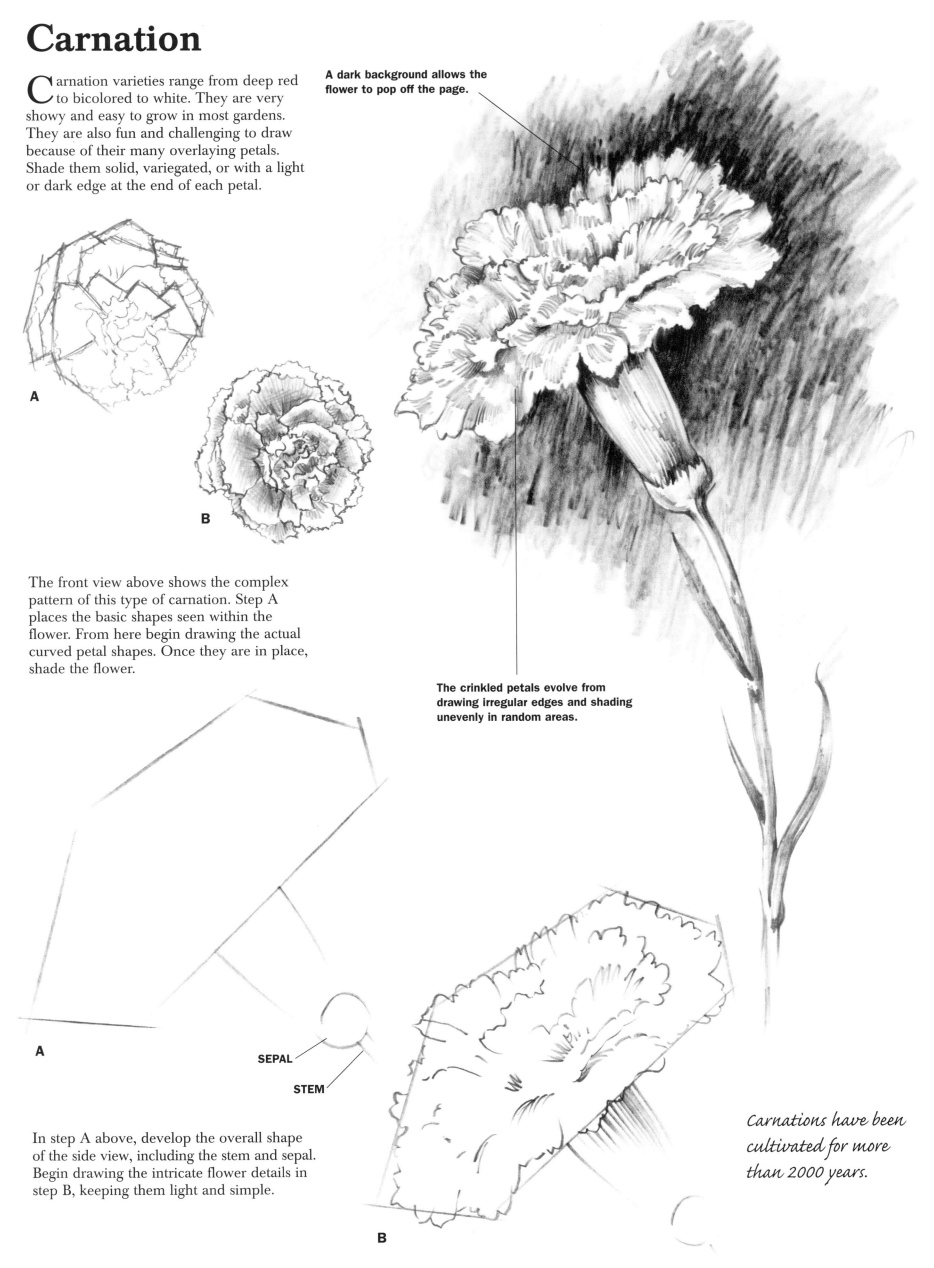

A dark background allows the flower to pop off the page.

A

B

The front view above shows the complex pattern of this type of carnation. Step A places the basic shapes seen within the flower. From here begin drawing the actual curved petal shapes. Once they are in place, shade the flower.

The crinkled petals evolve from drawing irregular edges and shading unevenly in random areas.

A

SEPAL

STEM

In step A above, develop the overall shape of the side view, including the stem and sepal. Begin drawing the intricate flower details in step B, keeping them light and simple.

B

Carnations have been cultivated for more than 2000 years.

English Wallflower

These velvety orange, red, and yellow flowers grow on bushy plants that can grow up to two feet high. There are several different types that range from dwarf to tall. Some varieties are even bicolored with darker tips.

A

B

Draw your preliminary lines lightly so they are easy to erase later.

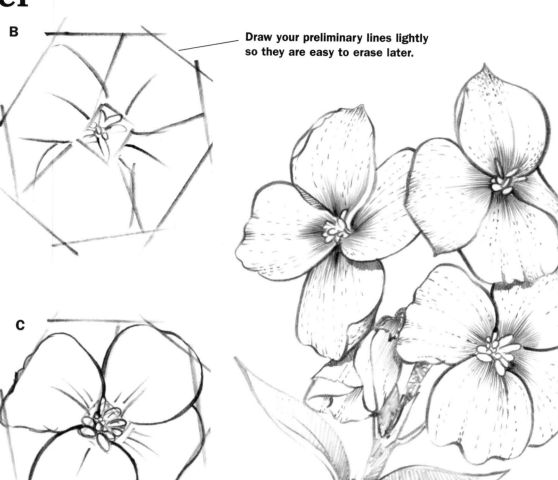

C

Follow the steps above closely, laying down the four large petals inside your block-in shape with straight lines. Start smoothing out the lines into the petal edges and filling in details; then lightly shade. Sometimes simple renderings like this present your subject best.

Begonia

There are single- and double-flowered begonias. The double-flowered variety is a bit more difficult to draw. Don't rush this flower because it's easy to lose your place. Study each step before drawing the flower yourself.

Begonias mainly bloom in summer and early autumn.

DOUBLE-FLOWERED

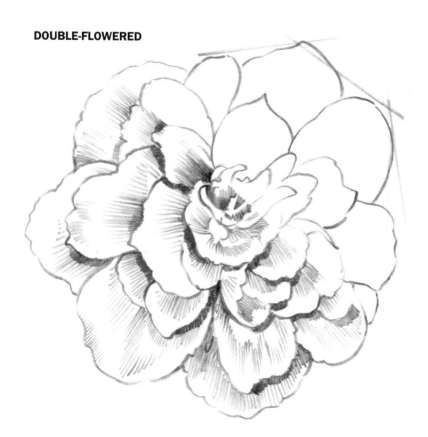

A

C

B

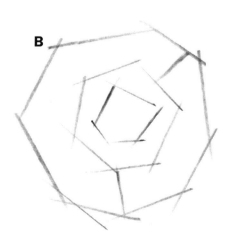

D

Finish shading the rest of the flower directly in the book.

Poppy

The beautiful California poppy grows in a variety of colors from deep orange to pale yellow. The blossoms are paper-like and delicate. The flower spreads about two inches wide. Use the diagram below to draw the whole plant, and follow the steps to the right for the individual flower.

Pansy

Pansies grow in many color combinations. Sometimes these combinations resemble faces, almost having expressions.

When drawing the pansy, use the steps to overlap the petals so each one slightly covers another near the edges. Notice how the dark shading near the center gives the illusion of the flower having two colors, as well as three-dimensional form.

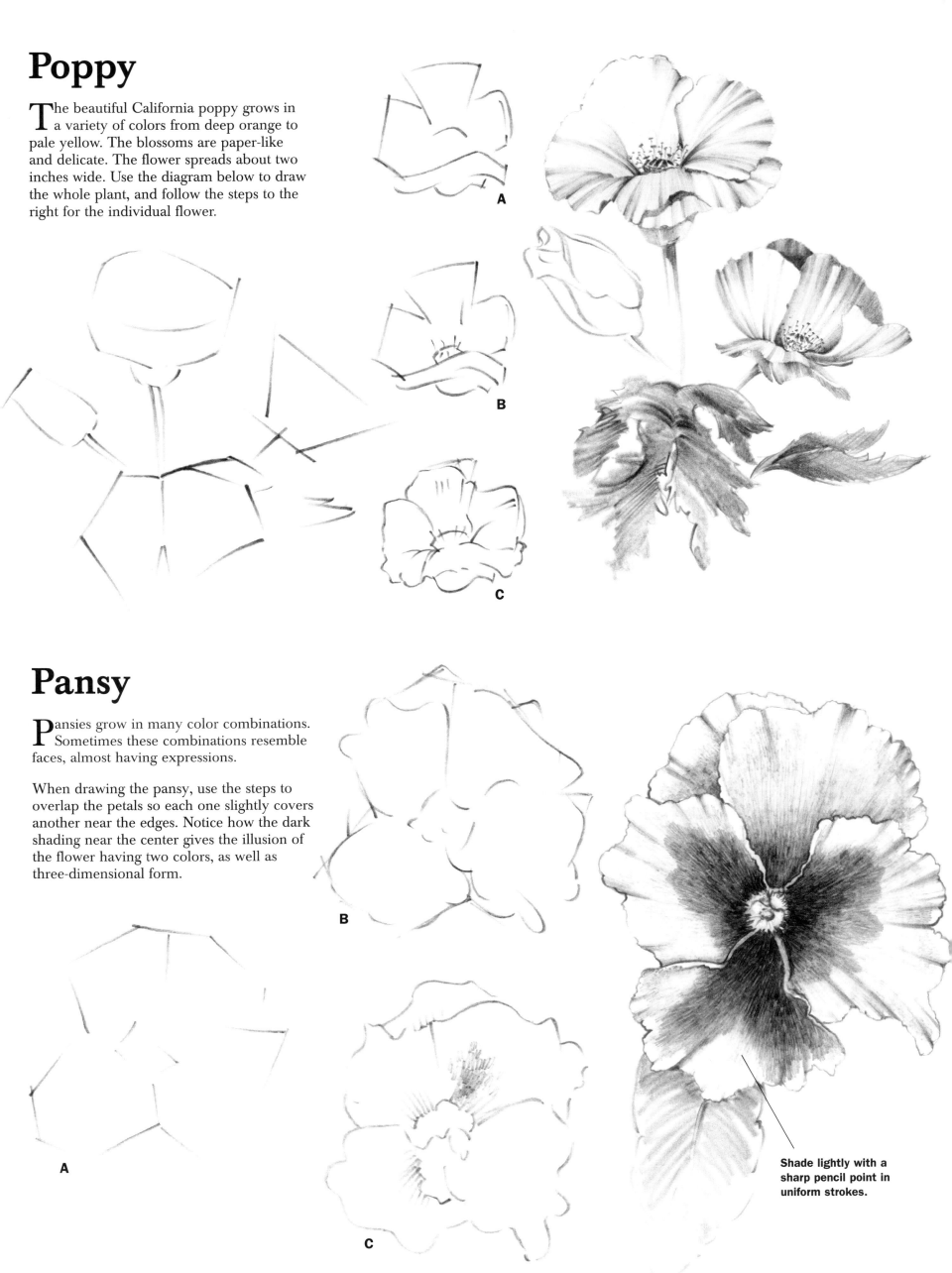

Shade lightly with a sharp pencil point in uniform strokes.

Dendrobium

The dendrobium is an orchid variety native to tropical climates. They have slender stems up to two feet long. Flowers grow 2½ to 3½ inches across. Colors range from blends of mauve, containing deeper colored veins, to maroon and pale purple.

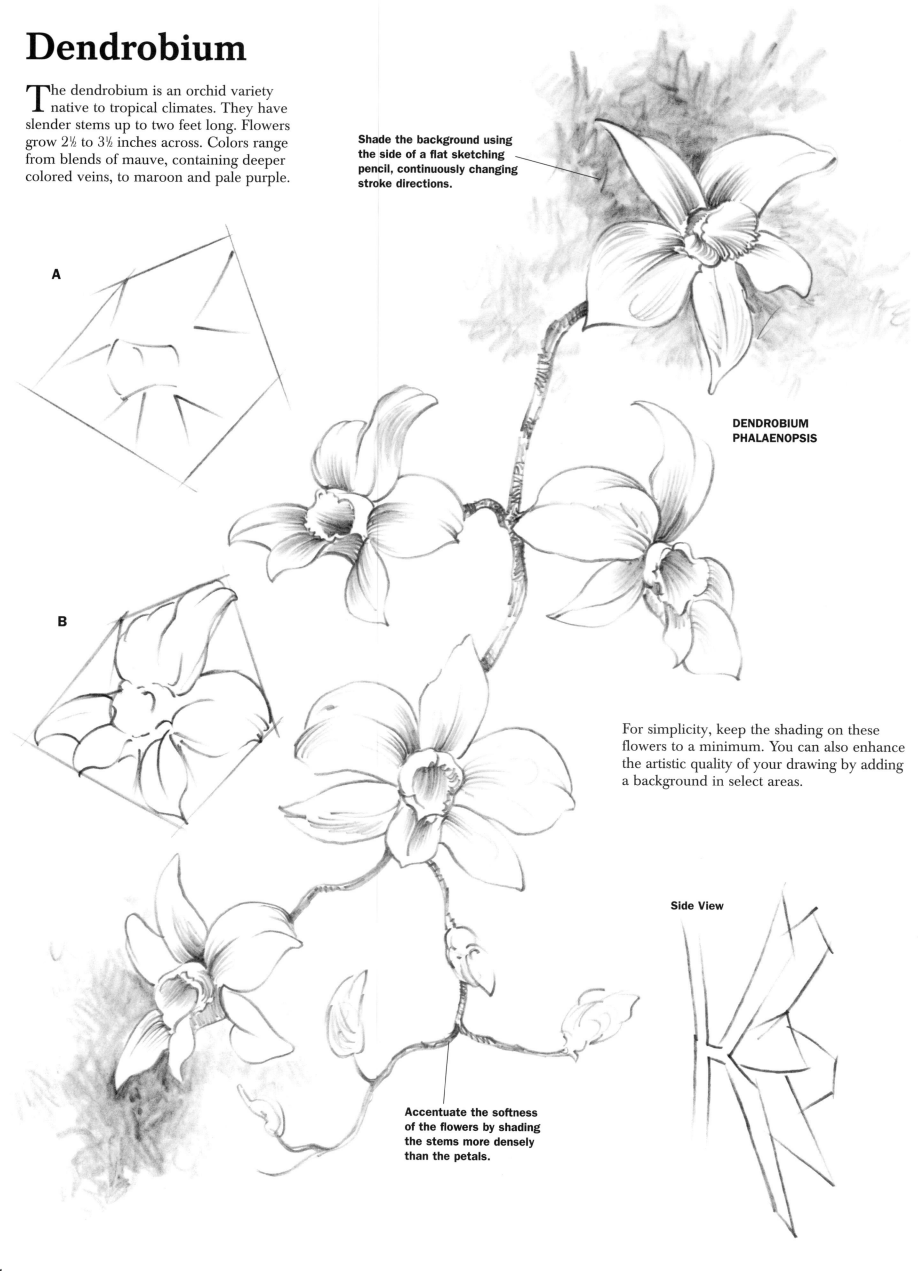

Shade the background using the side of a flat sketching pencil, continuously changing stroke directions.

A

B

DENDROBIUM PHALAENOPSIS

For simplicity, keep the shading on these flowers to a minimum. You can also enhance the artistic quality of your drawing by adding a background in select areas.

Side View

Accentuate the softness of the flowers by shading the stems more densely than the petals.

The flowers of the dendrobium dearei grow from 2 to 2½ inches across. The petals are oval-shaped with a pale yellow-green band.

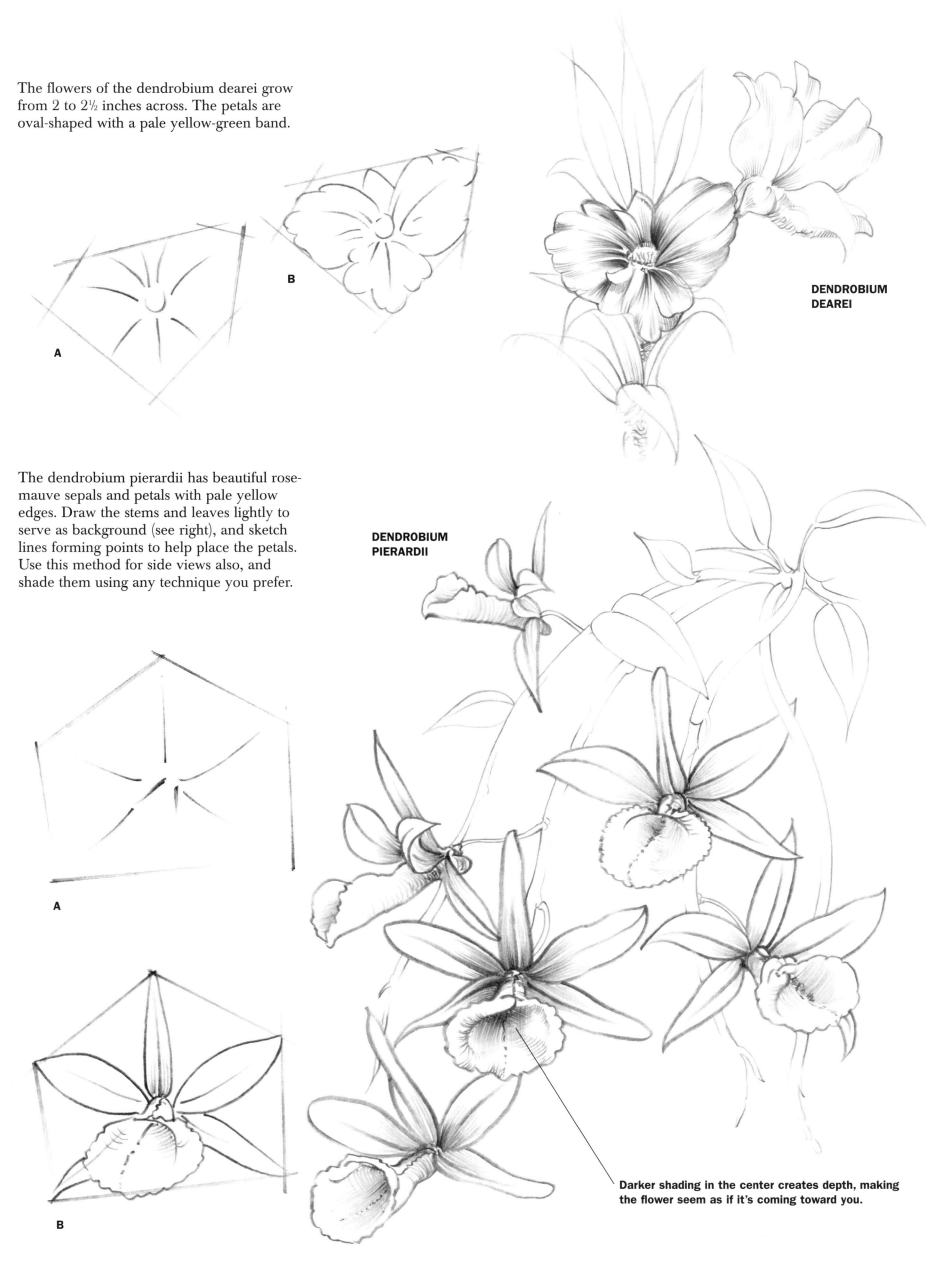

A

B

DENDROBIUM DEAREI

The dendrobium pierardii has beautiful rose-mauve sepals and petals with pale yellow edges. Draw the stems and leaves lightly to serve as background (see right), and sketch lines forming points to help place the petals. Use this method for side views also, and shade them using any technique you prefer.

DENDROBIUM PIERARDII

A

B

Darker shading in the center creates depth, making the flower seem as if it's coming toward you.

Primrose

There are many primrose varieties with a wide range of colors. This exercise demonstrates how to draw a number of flowers and buds together. Take your time when placing them.

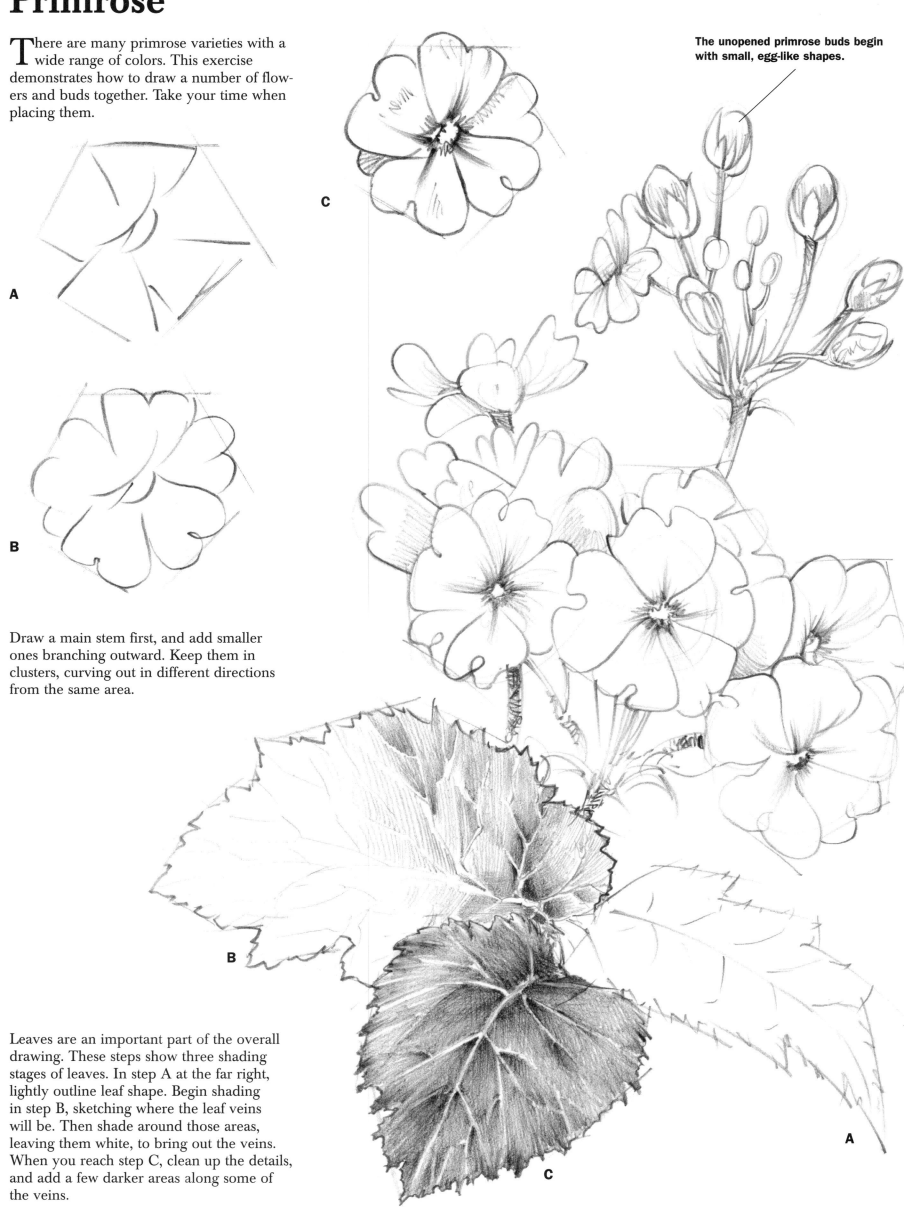

The unopened primrose buds begin with small, egg-like shapes.

Draw a main stem first, and add smaller ones branching outward. Keep them in clusters, curving out in different directions from the same area.

Leaves are an important part of the overall drawing. These steps show three shading stages of leaves. In step A at the far right, lightly outline leaf shape. Begin shading in step B, sketching where the leaf veins will be. Then shade around those areas, leaving them white, to bring out the veins. When you reach step C, clean up the details, and add a few darker areas along some of the veins.

Hibiscus

Hibiscus grow in single- and double-flowered varieties, and their colors include whites, oranges, pinks, and reds—even blues and purples. Some are multi- or bicolored.

Even though the hibiscus has a lot of detail, it isn't difficult to draw. Steps leading up to the finished drawing must be followed closely to get the most out of this exercise. Step A shows the overall mass, petal direction, and basic center of the flower. Consider the size of each flower part in relation to the whole before attempting to draw it.

Before shading the petals in step B, study where the shading falls and how it gives the petals a slightly rippled effect. Add the details of the flower center, and block in the stem and leaves.

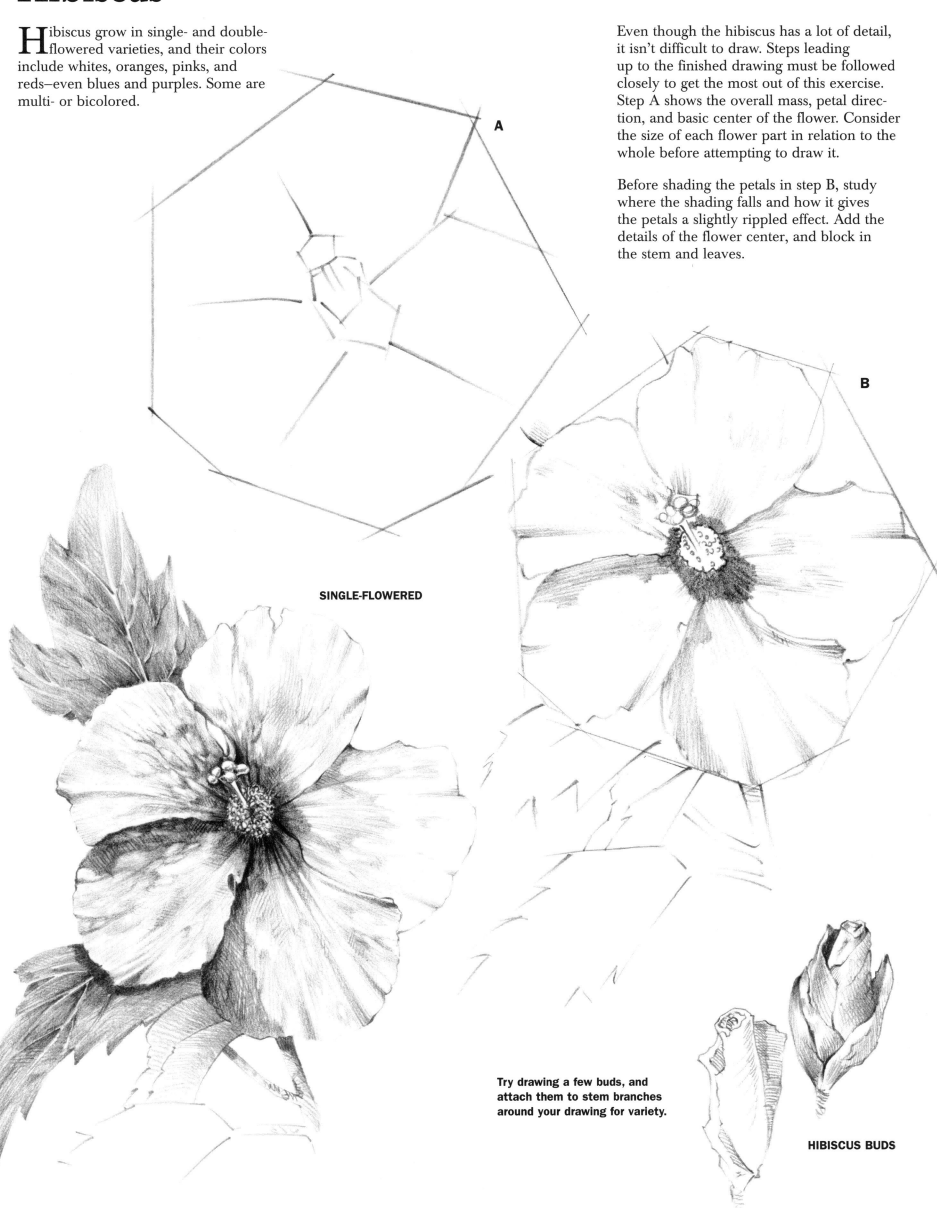

SINGLE-FLOWERED

Try drawing a few buds, and attach them to stem branches around your drawing for variety.

HIBISCUS BUDS

17

Fuchsia

Fuchsias present beautiful color variety, including greens, reds, and purples. This exercise should be drawn on vellum-finish (rough) bristol board to enhance the irregular texture of the flowers. Use the side of an HB pencil to lightly block in the basic shapes, and build the details of the petal pattern.

Start light shading using the tip of an HB pencil, making certain to shade with the surface direction. Develop large shading areas using the side of the lead, and darken creases and lines using a sharpened 2B.

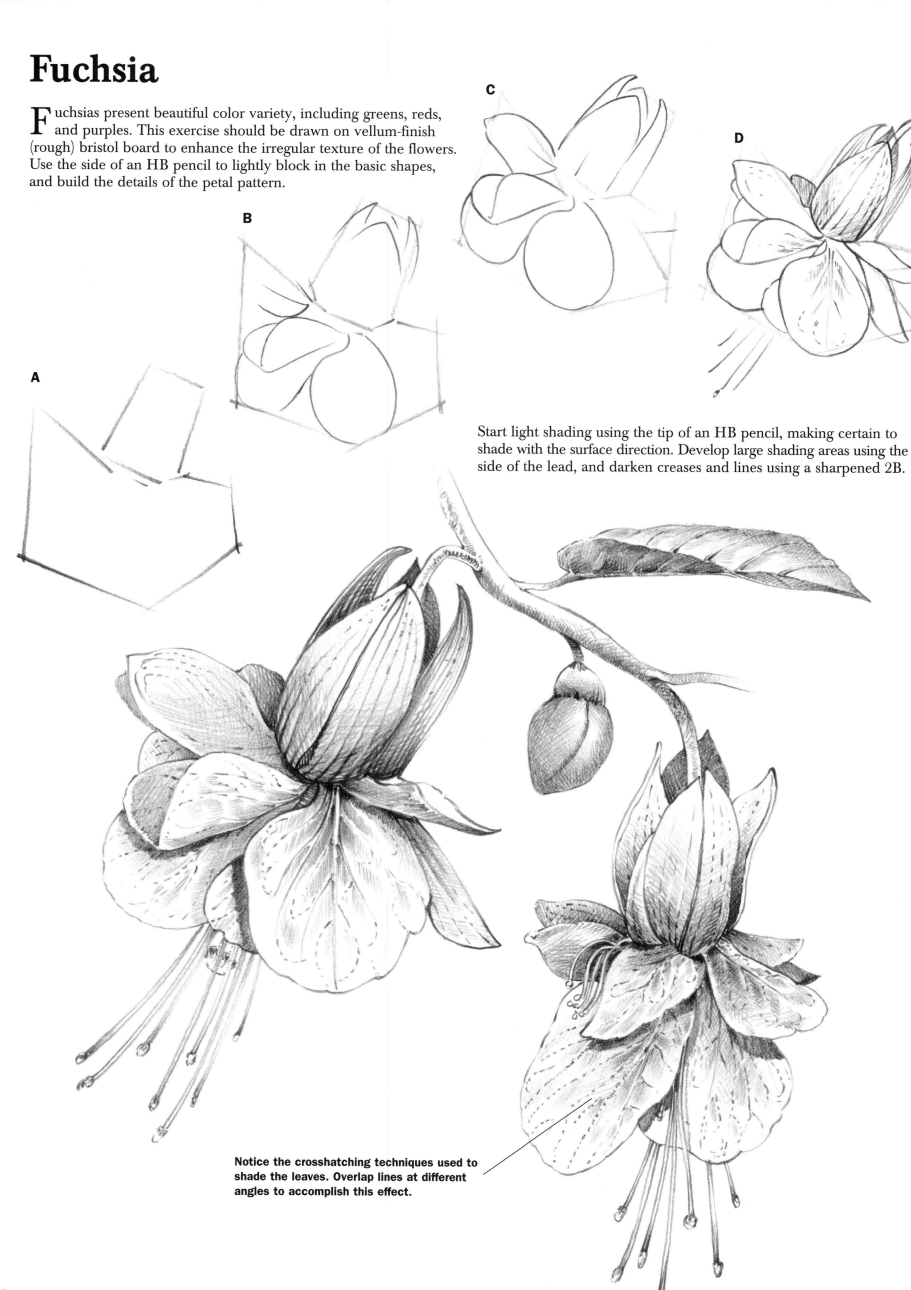

Notice the crosshatching techniques used to shade the leaves. Overlap lines at different angles to accomplish this effect.

Peony

Peonies also grow in single- and double-flowered varieties. They are a showy flower and make fine subjects for flower drawings.

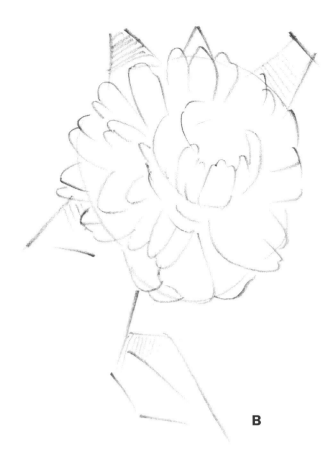

B

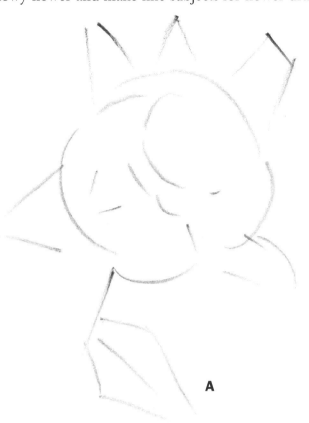

A

This exercise should be drawn on vellum-finish bristol board. On this surface, shading produces a bit more texture than the smoother plate finish. Begin the exercise by drawing and positioning the major flower parts in step A. In step B, begin shading the petals and surrounding leaves. Start shading in earnest in step C, and establish the background pattern.

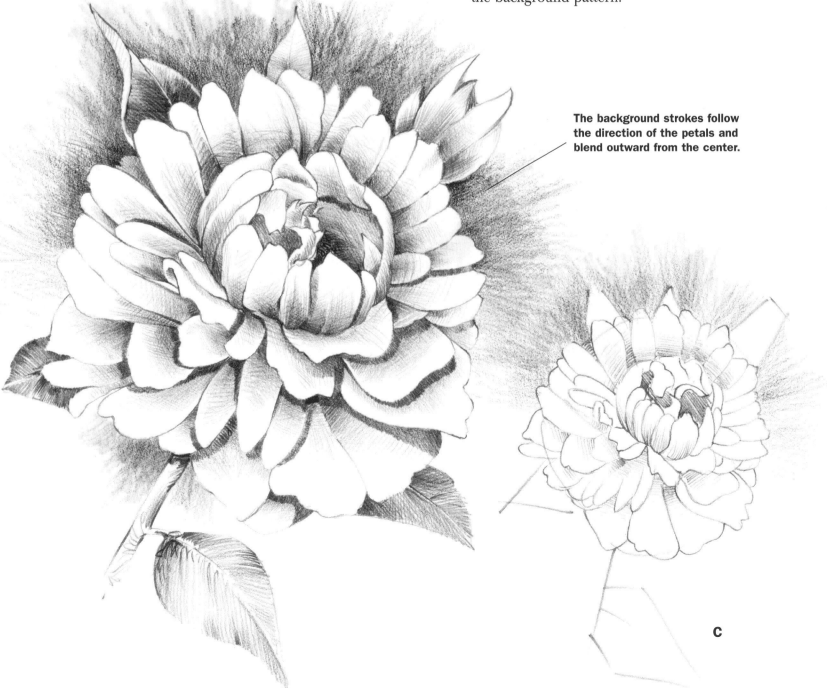

The background strokes follow the direction of the petals and blend outward from the center.

C

Foxglove

Foxgloves are tall, erect, biennial plants. Their flowers are long and tubular with white, yellow, rose, or purple flowers that usually contain a dotted pattern on the inside. Use the diagrams below to block in each flower connected to a long, draping stem.

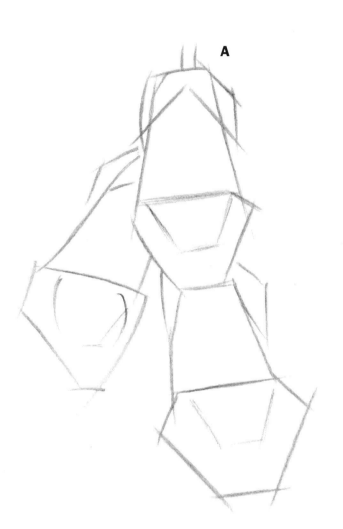

A

Be confident with your preliminary block-in lines!

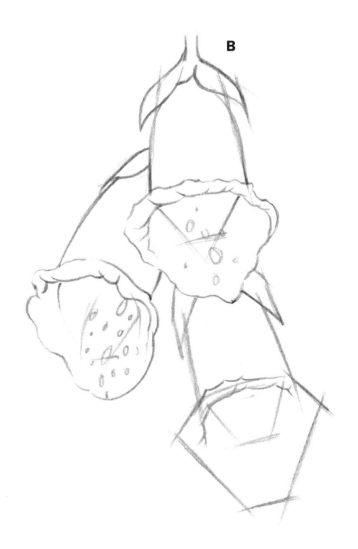

B

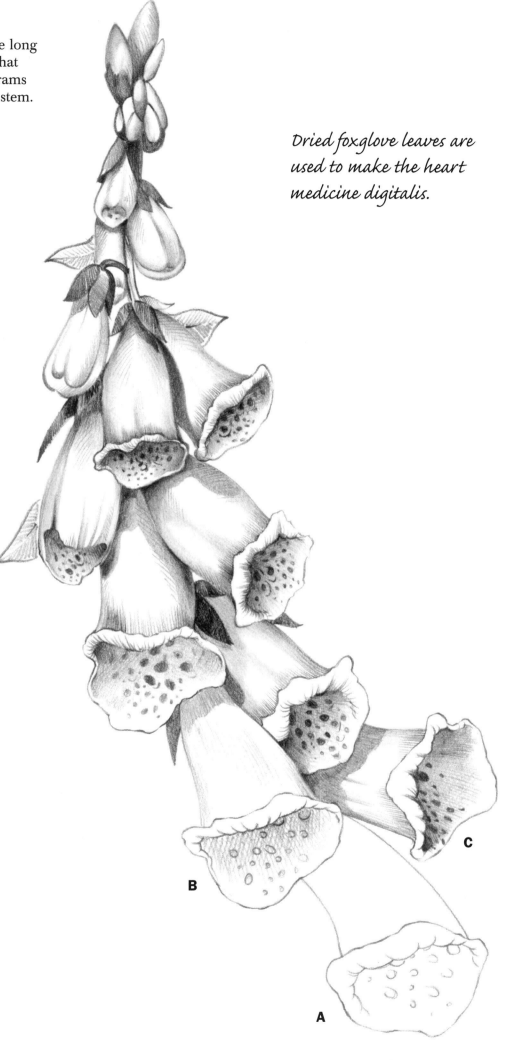

Dried foxglove leaves are used to make the heart medicine digitalis.

C

B

A

Don't begin shading until all flowers are in place, because some flowers cast shadows on others. Follow steps A through C on the bottom three flowers for shading. Start with tiny circles to create the dot pattern inside the flower, then slowly shade around them. For the outside of the flowers, use the flat side of an HB pencil, applying crosshatching lines around the edges to give the blossoms a three-dimensional appearance.

Columbine

The columbine is an unusual flower with long protrusions known as spurs. These spurs are very important to butterflies and hummingbirds because each tip contains a drop of nectar.

Follow the steps below carefully when drawing the leaves. In step A, notice the sharp angles in the initial shapes and how the leaves develop from them in steps B and C.

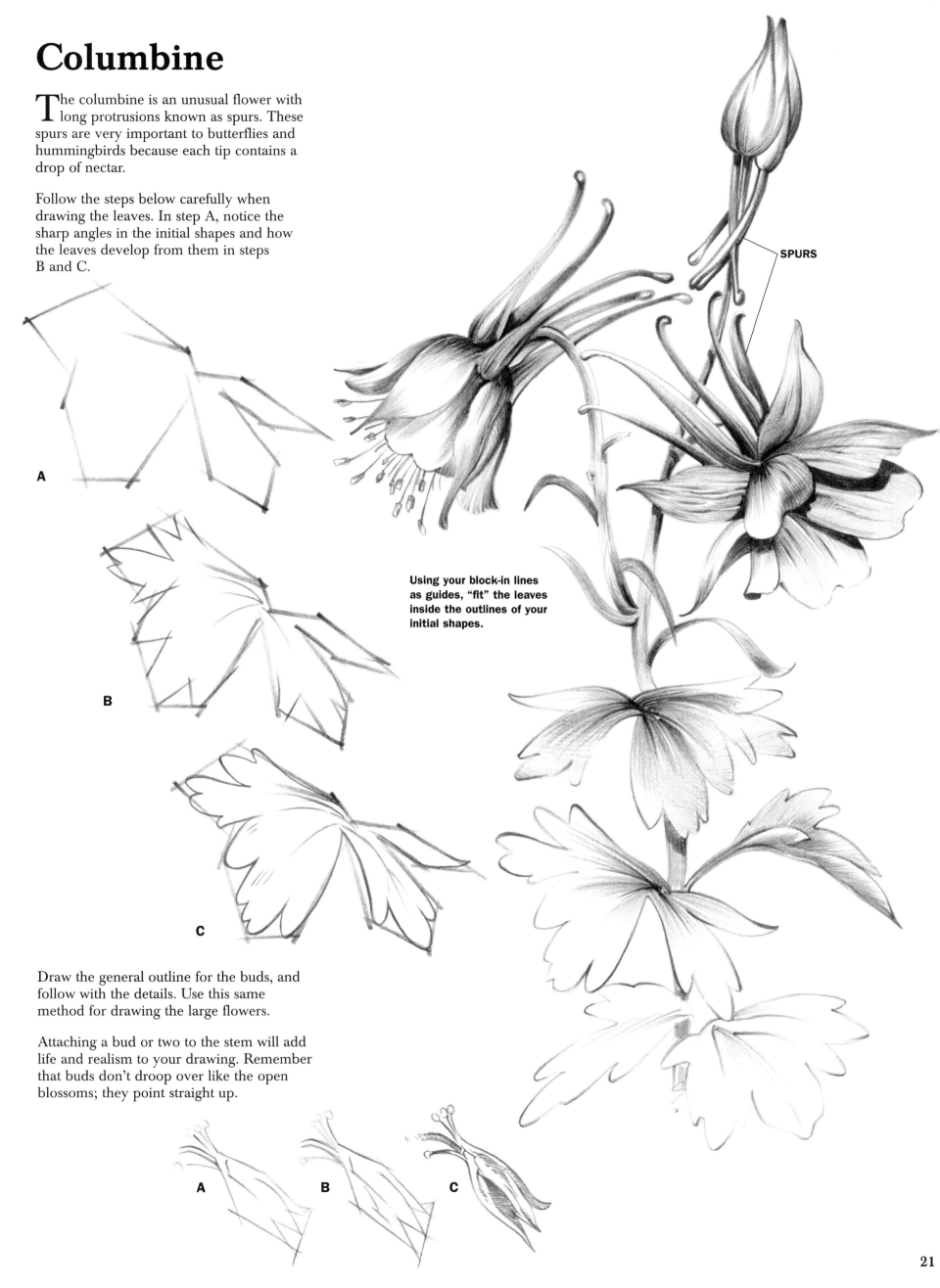

SPURS

A

B

C

Using your block-in lines as guides, "fit" the leaves inside the outlines of your initial shapes.

Draw the general outline for the buds, and follow with the details. Use this same method for drawing the large flowers.

Attaching a bud or two to the stem will add life and realism to your drawing. Remember that buds don't droop over like the open blossoms; they point straight up.

A B C

Hybrid Tea Rose

Hybrid tea roses have large blossoms with greatly varying colors. When drawing rose petals, think of each fitting into its own place in the overall shape; this helps position them correctly. Begin lightly with an HB pencil, and use plate-finish bristol board.

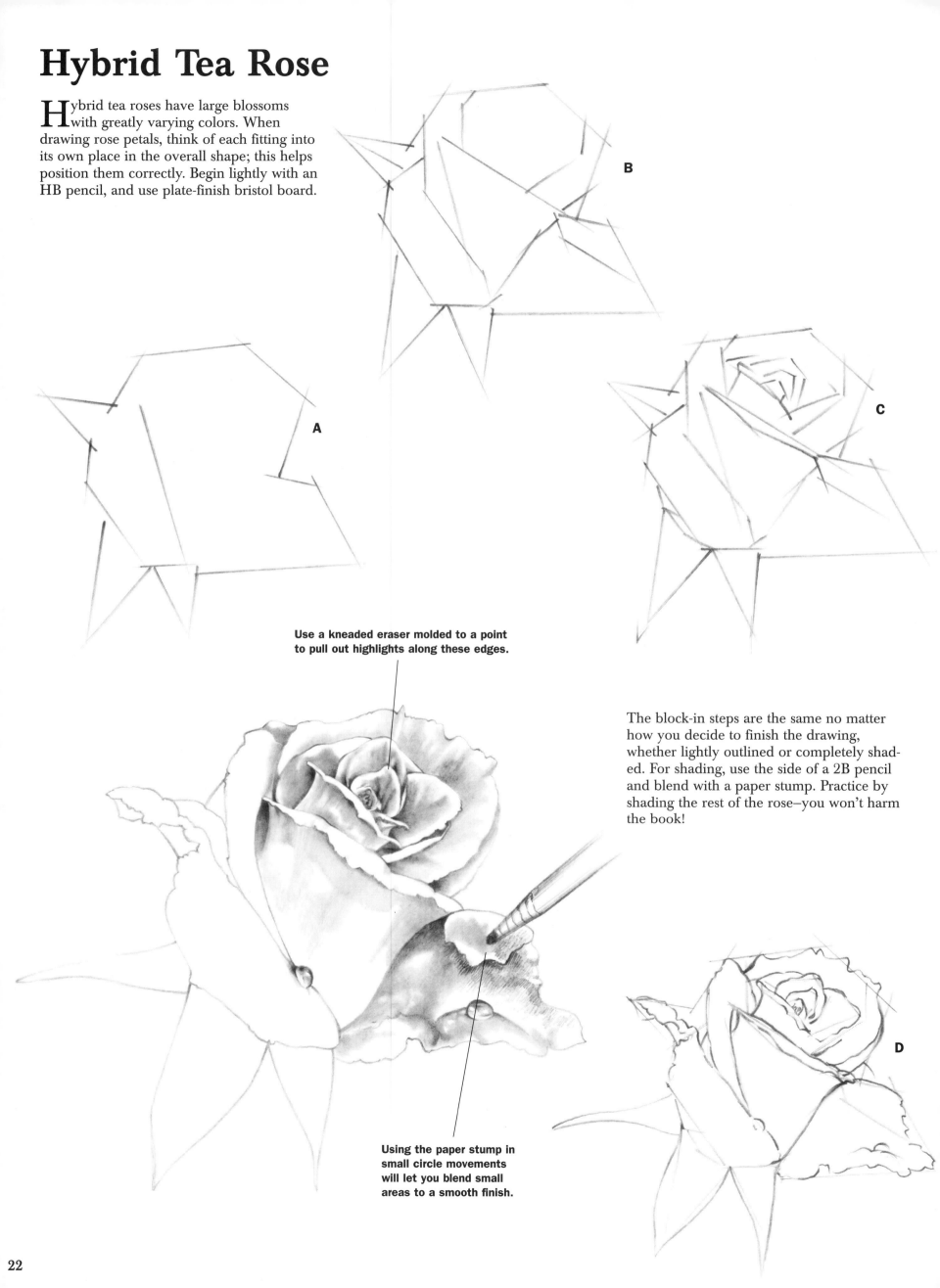

B

A

C

Use a kneaded eraser molded to a point to pull out highlights along these edges.

The block-in steps are the same no matter how you decide to finish the drawing, whether lightly outlined or completely shaded. For shading, use the side of a 2B pencil and blend with a paper stump. Practice by shading the rest of the rose—you won't harm the book!

Using the paper stump in small circle movements will let you blend small areas to a smooth finish.

D

Floribunda Rose

Floribunda roses usually flower more freely than hybrid tea roses and grow in groups of blossoms. The petal arrangement in these roses is involved; but by studying it closely, you'll see an overlapping, swirling pattern.

Use a blunt-pointed HB pencil lightly on plate-finish bristol board. Outline the overall area of the rose mass in step A. Once this is done, draw the swirling petal design as shown in steps B and C. Begin fitting the center petals into place in step D. Use the side of an HB to shade as in step E, being careful not to cover the water drops. They should be shaded separately.

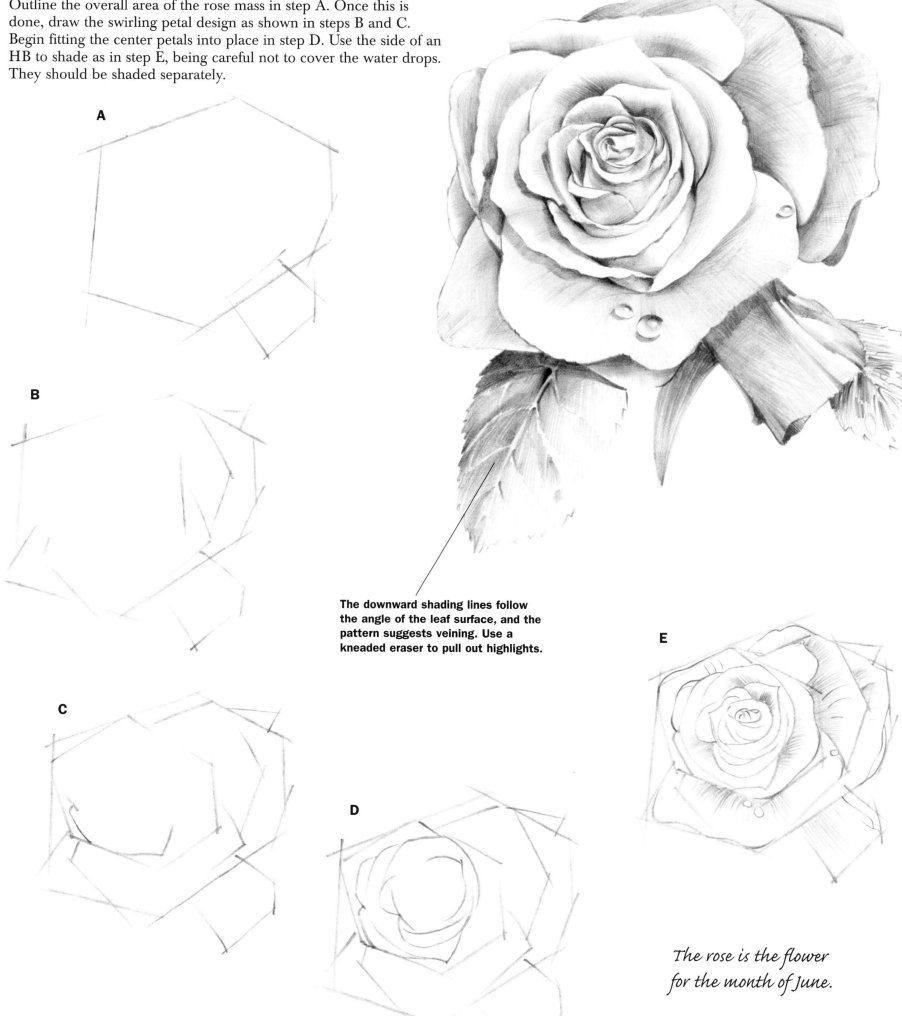

A

B

C

D

E

The downward shading lines follow the angle of the leaf surface, and the pattern suggests veining. Use a kneaded eraser to pull out highlights.

The rose is the flower for the month of June.

Thistle

Of the many thistle species, the one shown here is the *cirsium muticum*. It's a popular, purple-flowered specimen that can be found in fields and low-lying pastures. The prickly sides are a drawing challenge because you must render a wide range of surface textures. The side of the flower is prickly while the flower is soft and delicate. Use both HB and 2B pencils in this exercise, and draw on plate-finish bristol board.

The empty areas help suggest that the quills are spread out and full.

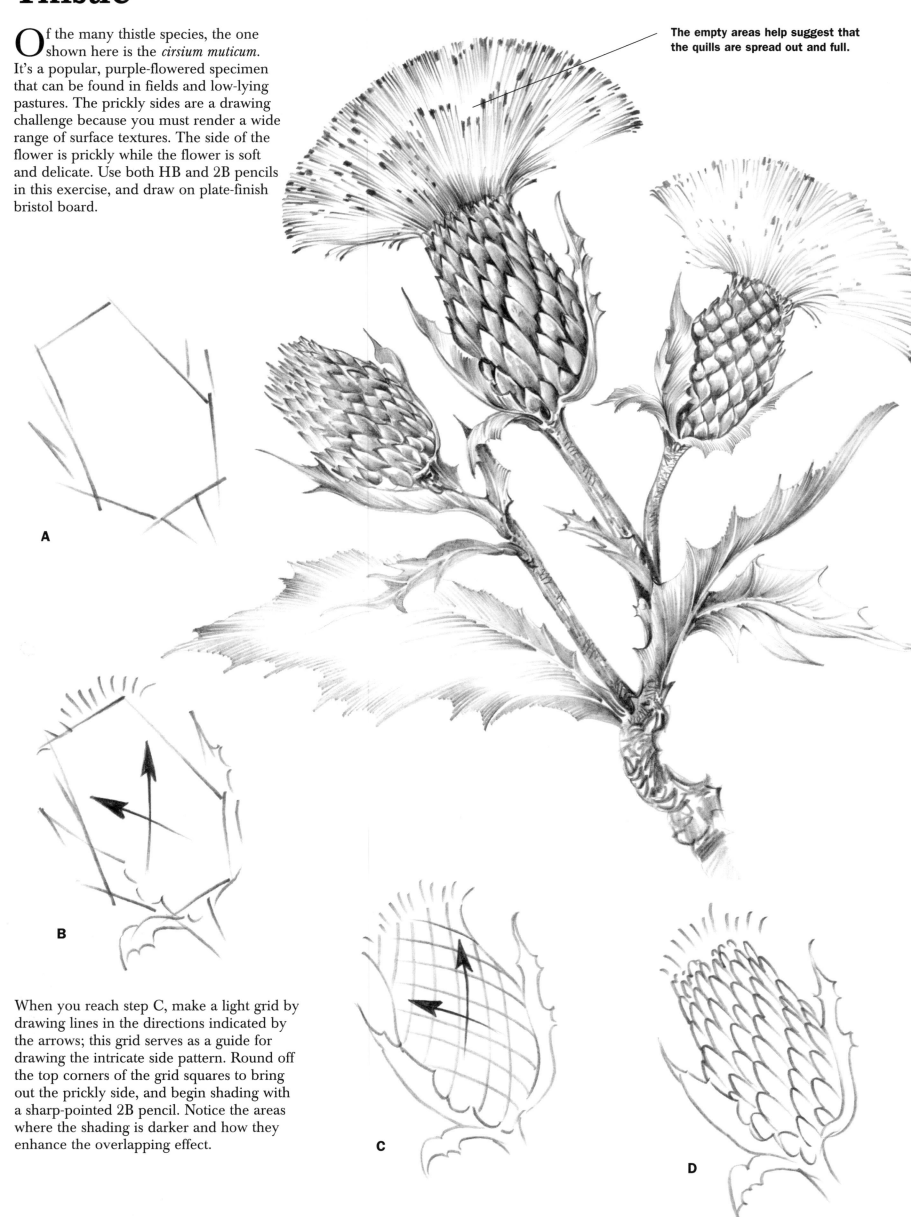

When you reach step C, make a light grid by drawing lines in the directions indicated by the arrows; this grid serves as a guide for drawing the intricate side pattern. Round off the top corners of the grid squares to bring out the prickly side, and begin shading with a sharp-pointed 2B pencil. Notice the areas where the shading is darker and how they enhance the overlapping effect.

Bleeding Heart

The bleeding heart blooms beautifully in arching sprays and produces pink or white blossoms. The flowers are locket-shaped and dangle from curved stems like a necklace.

Try these drawings on vellum-finish bristol board with an HB pencil. The tooth of this finish makes the HB appear darker than the plate finish.

In step A below, use a diamond pattern to block in the lower part of the flowers. Once they are established, round off the edges, as shown in step B.

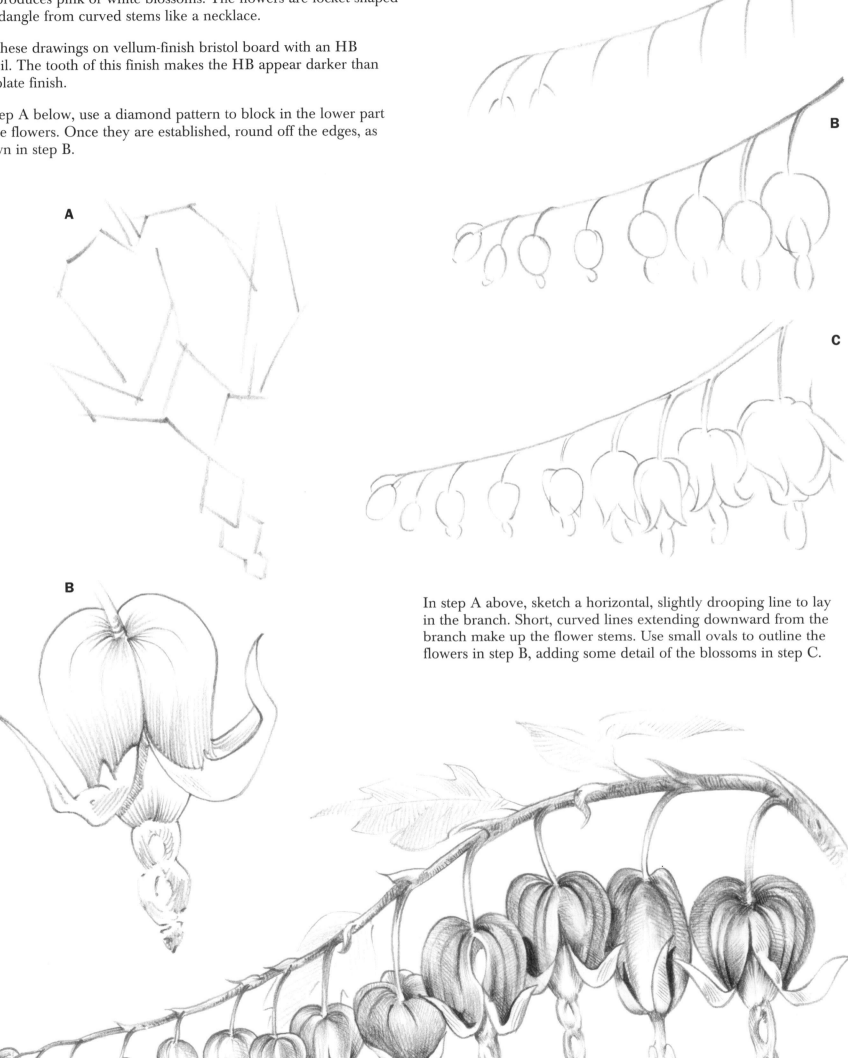

A

B

C

A

B

In step A above, sketch a horizontal, slightly drooping line to lay in the branch. Short, curved lines extending downward from the branch make up the flower stems. Use small ovals to outline the flowers in step B, adding some detail of the blossoms in step C.

Chrysanthemums

The two varieties of chrysanthemums on this page are the pompon and the Japanese anemone. The pompon chrysanthemum produces flowers one to two inches across and are more button-like than the larger, more globular types.

The Japanese anemone grows four inches or more across and produces flowers with irregular outlines and, in some cases, resembles forms of anemone sea life.

Follow the steps for each flower type, trying to capture the attitude and personality of each flower and petal formation. It's best to draw this exercise on plate-finish bristol board using both HB and 2B pencils. Smooth bond paper also provides a good drawing surface.

Observe the difference in texture between the top of the Japanese anemone blossom below and its sides. The voluminous, bushy effect is achieved with many short, squiggly lines drawn in random directions, in contrast to the sloping lines of the lower petals.

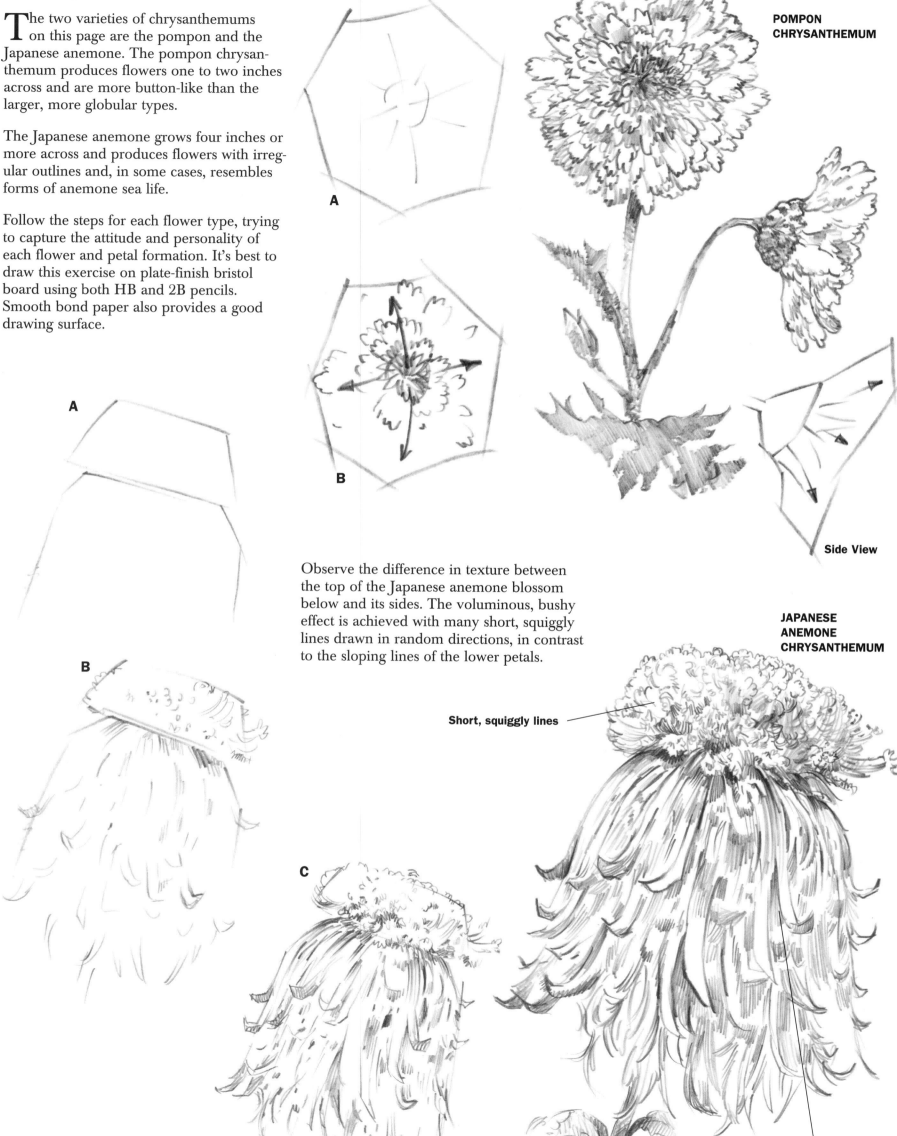

POMPON CHRYSANTHEMUM

A

B

Side View

JAPANESE ANEMONE CHRYSANTHEMUM

Short, squiggly lines

Long, drooping lines

A

B

C

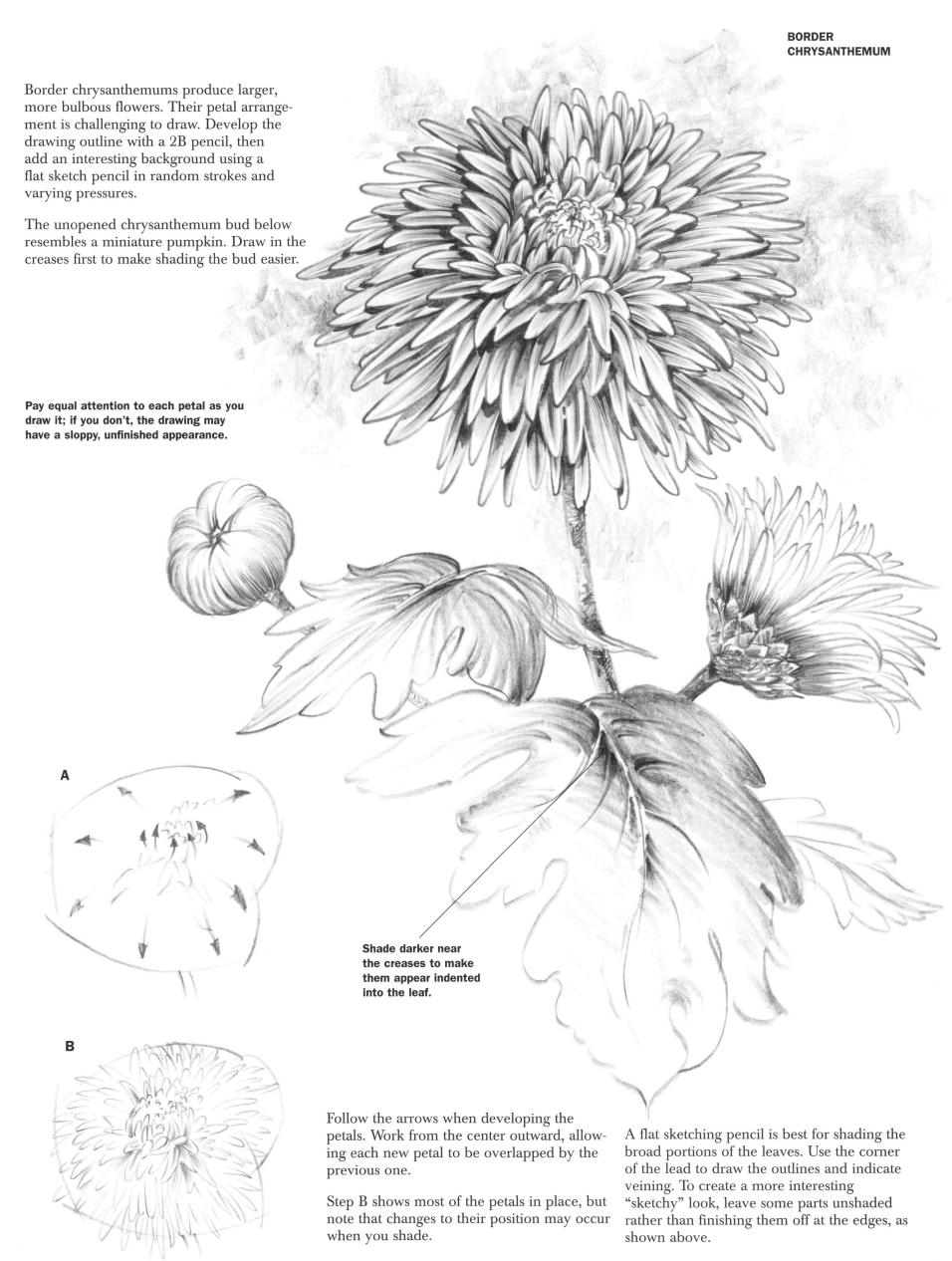

Border chrysanthemums produce larger, more bulbous flowers. Their petal arrangement is challenging to draw. Develop the drawing outline with a 2B pencil, then add an interesting background using a flat sketch pencil in random strokes and varying pressures.

The unopened chrysanthemum bud below resembles a miniature pumpkin. Draw in the creases first to make shading the bud easier.

Pay equal attention to each petal as you draw it; if you don't, the drawing may have a sloppy, unfinished appearance.

A

Shade darker near the creases to make them appear indented into the leaf.

B

Follow the arrows when developing the petals. Work from the center outward, allowing each new petal to be overlapped by the previous one.

Step B shows most of the petals in place, but note that changes to their position may occur when you shade.

A flat sketching pencil is best for shading the broad portions of the leaves. Use the corner of the lead to draw the outlines and indicate veining. To create a more interesting "sketchy" look, leave some parts unshaded rather than finishing them off at the edges, as shown above.

27

Asters

These three types of asters should be drawn on plate-finish bristol board using both HB and 2B pencils. Note differences in the overall formation of each one. Use the block-in methods you've learned in the previous exercises before shading.

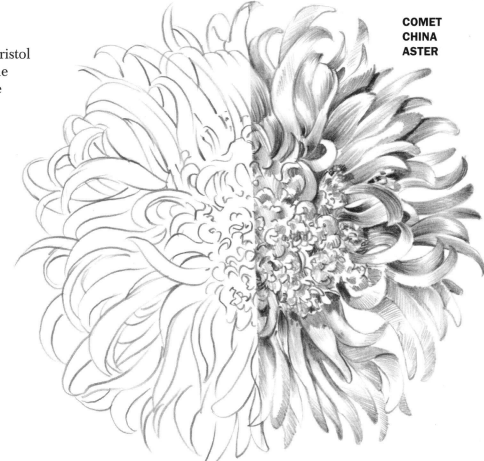

COMET CHINA ASTER

A

QUILLED CHINA ASTER

The left side of the drawing above shows careful crafting and placement of individual petals. While this is time-consuming, the overall result of this polished technique is worth the effort. Once the drawing is finished, shade the flower using smooth lines, as shown on the right side.

NEEDLE CHINA ASTER

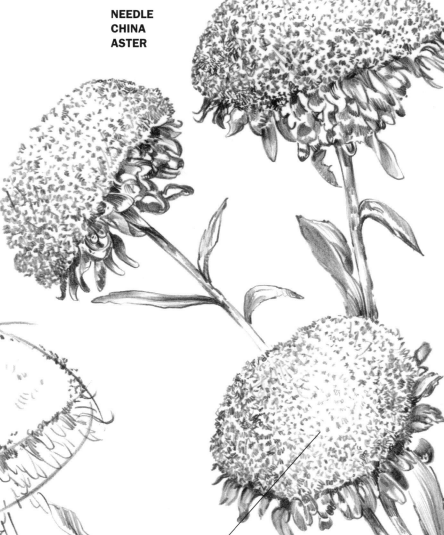

Use mostly dots and circles to shade the needle China aster, giving it a puffy look. Draw the dots densely for darker areas and sparsely for lighter ones. The resulting rough texture nicely contrasts with the gradual blends on the petals and leaves. Use a kneaded eraser molded to a point to accent highlights.

A

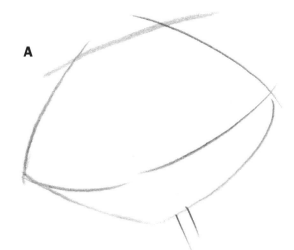

B

Sparser dots create the illusion of light within the flower and also give it form.

Gladiolus

Gladiolus can grow to a height of two to six feet, and their flowers range from two to six inches across. Petals can be smooth, flaring, wavy, or ruffled.

Draw on plate-finish bristol board using HB, 2B, and flat sketching pencils. Block in the flower and begin shading using the side of the HB, blending with a paper stump. Draw subtle texture lines using the sharp point of an HB, filling in shadows with a 2B.

Shade the background with a flat sketching pencil, using random strokes. Then apply crosshatching in small areas with a sharp-pointed 2B. Finally, lift out highlights with a kneaded eraser.

Every block-in line is important, especially when drawing closely overlapped petals. Put your observation skills to the test!

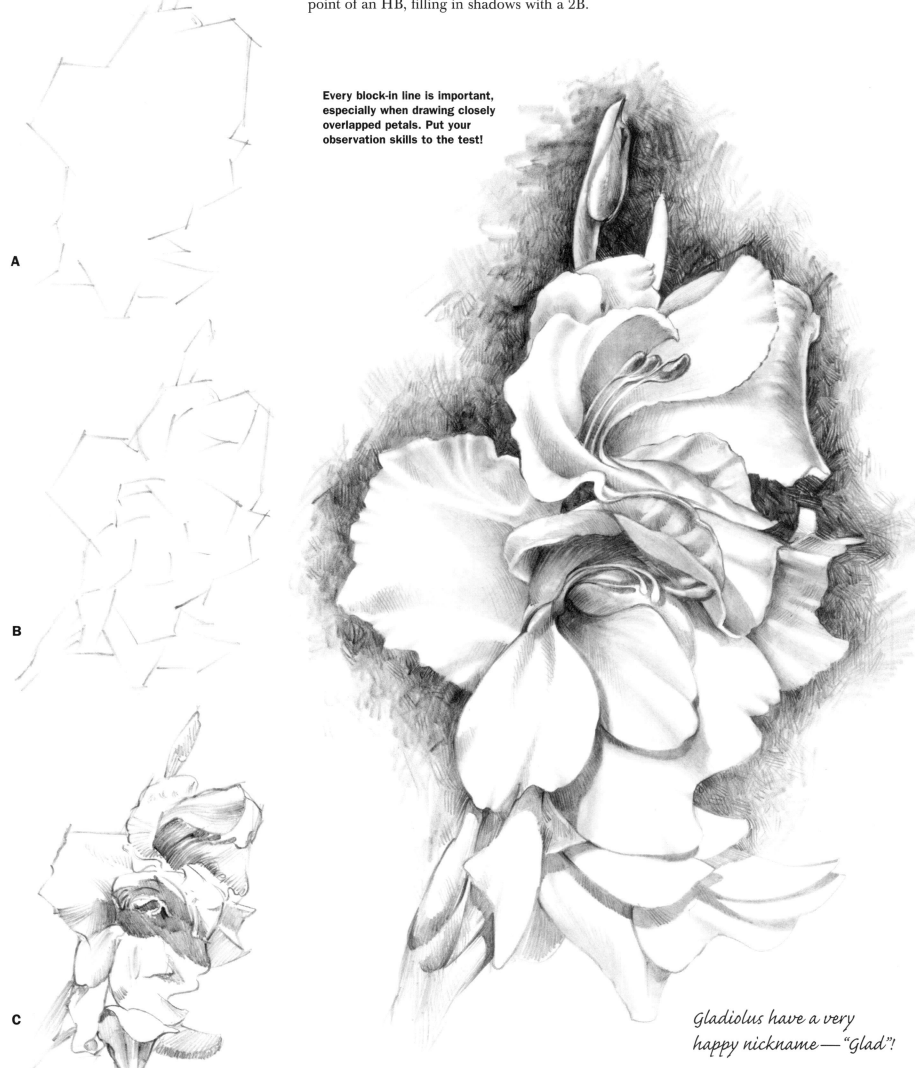

A

B

C

Gladiolus have a very happy nickname — "Glad"!

Bearded Iris

The bearded iris is probably the most beautiful of the iris varieties. Its colors range from deep purples to blues, lavenders, and whites. Some flowers have delicate, lightly colored petals with dark veining. They range in height from less than a foot to over three feet.

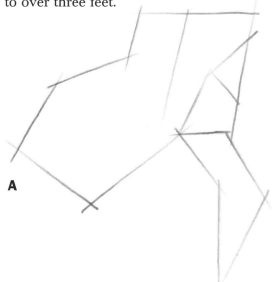

A

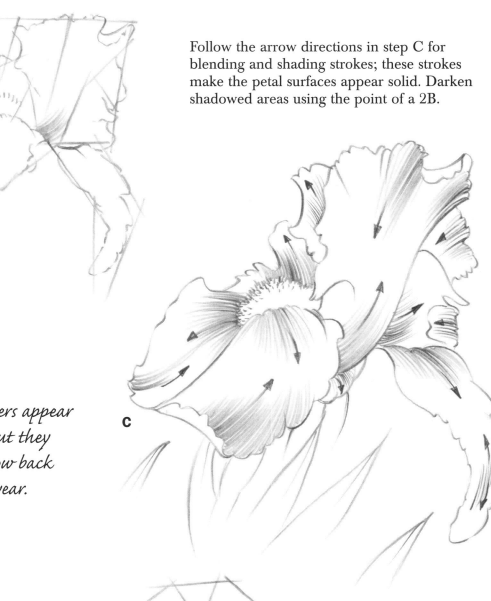

B

Follow the arrow directions in step C for blending and shading strokes; these strokes make the petal surfaces appear solid. Darken shadowed areas using the point of a 2B.

C

Step A above shows the block-in lines for a side view of the iris, while step A below right shows a frontal view. Whichever you choose to draw, make your initial outline shapes light, and use them as a general guide for drawing the graceful curves of this flower's petals.

These flowers appear delicate, but they usually grow back year after year.

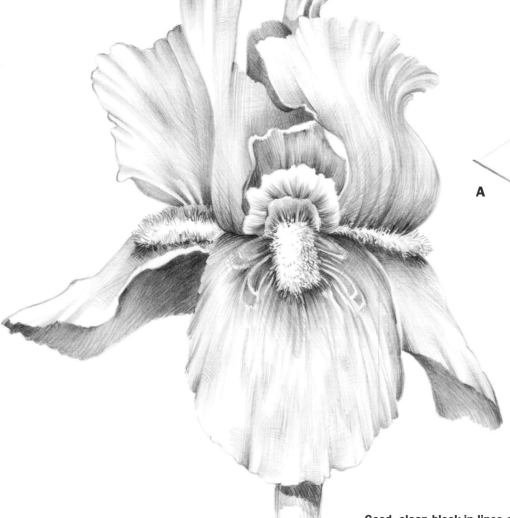

A

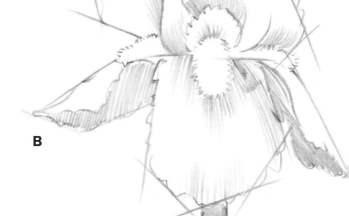

B

Good, clean block-in lines are helpful for shading an involved subject. Take your time, and plan ahead to save correction time.

This final drawing is quite involved, but it's no more difficult than the previous drawings. It just has more flowers and shading steps. Once again, we must first draw the overall layout of the flowers before attempting any shading.

Sketch the ridge lines in the petals; they are necessary for accurate shading. Develop the shading in stages, filling in the grooved areas first. Then make the whole flower slightly grayer, by adding what is known as a "glaze"

over it. To glaze, use the side of an HB lead very lightly, shading with smooth, even strokes over completed sections of the drawing. To make petal surfaces appear even smoother, blend them with a paper stump.

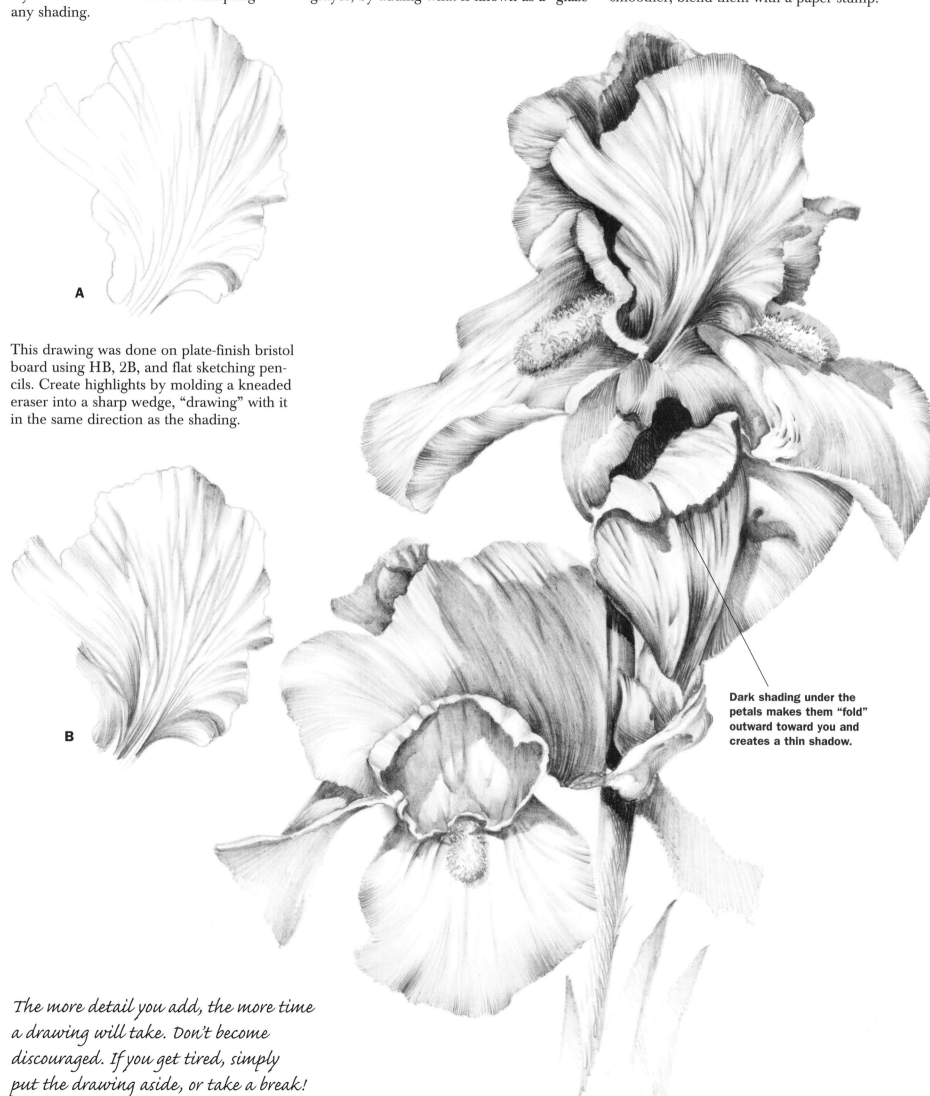

A

This drawing was done on plate-finish bristol board using HB, 2B, and flat sketching pencils. Create highlights by molding a kneaded eraser into a sharp wedge, "drawing" with it in the same direction as the shading.

B

Dark shading under the petals makes them "fold" outward toward you and creates a thin shadow.

The more detail you add, the more time a drawing will take. Don't become discouraged. If you get tired, simply put the drawing aside, or take a break!

More Ways to Learn

Collector's Series

Artist's Library

The **Artist's Library** series offers both beginning and advanced artists many opportunities to expand their creativity, conquer technical obstacles, and explore new media. You'll find in-depth, thorough information on each subject or art technique featured in the book. The books are written and illustrated by well-known artists who are qualified to help take eager learners to new levels of expertise.

Paperback, 64 pages, 6-1/2" x 9-1/2"

The **Collector's** series books are excellent additions to any library, offering a comprehensive selection of projects drawn from the most popular titles in our How to Draw and Paint series. These books take the fundamentals of a particular medium, then further explore the subjects, styles, and techniques of featured artists.

CS01, CS02, CS04: Paperback, 144 pages, 9" x 12"
CS03: Paperback, 224 pages, 10-1/4" x 9"

How to Draw and Paint

The **How to Draw and Paint** series is an extensive collection of stunning titles, covering every subject and medium and meeting any beginning artist's needs. Specially written to encourage and motivate, these books offer essential information in an easy-to-follow format. Lavishly illustrated with beautiful drawings and gorgeous art, this series both instructs and inspires the aspiring artist.

Paperback, 32 pages, 10-1/4" x 13-3/4"

Walter Foster products are available at art and craft stores everywhere. Write or call for a FREE catalog that includes all of Walter Foster's titles. Or visit our website at www.walterfoster.com

Walter Foster®

Walter Foster Publishing, Inc. • 23062 La Cadena Drive • Laguna Hills, CA 92653 • (800) 426-0099